BRIGHTON
THROUGH TIME
Judy Middleton

First published 2009

Amberley Publishing Plc
Cirencester Road, Chalford,
Stroud, Gloucestershire, GL6 8PE

www.amberley-books.com

British Library Cataloguing in Publication Data.
A catalogue record for this book is available from the British Library.

ISBN 978 1 84868 122 4

Typesetting and Origination by Amberley Publishing.
Printed in Great Britain.

BRIGHTON
THROUGH TIME
Judy Middleton

AMBERLEY PUBLISHING

The Aquarium, Brighton.

Acknowledgements

Thanks to Rodney Roodt of the Royal Albion Hotel for assistance in taking a photograph from the window of that hotel.

The Fountain, Old Steine
Brighton.

With Best Wishes.

Introduction

It cannot be claimed that there has been a shortage of books about Brighton but it is such a multi-faceted place that there is always room for a book with a different outlook. There have been other 'then and now' books, of course, just as there have been books of modern colour photographs. But there has not been one to combine the two. Colour adds an extra dimension and as many old coloured postcards as possible have been chosen. This book presents a nostalgic look at postcard views people wanted to send home, together with an equivalent modern view.

The Edwardian postcard was used much as we send text messages today. The post was so reliable that postcards were bound to arrive speedily. In fact, messages such as 'see you tomorrow' or 'arrived safely' were more common than the 'wish you were here' type. A few postcards were more formal, some like an outdoor studio portrait and others portraying a corporate outing. These were printed in black and white or sepia tones because only a small number were produced.

It is still a popular myth that Brighton was a small fishing village until discovered by the Prince Regent. The reality is that it has long been a place of importance in Sussex. There have been advantages and disadvantages to being a seaside town. For instance, by 1340 the town had lost 40 acres of land to the sea, and French raiders arrived in the sixteenth century, culminating in the terrible raid of 1514 when most of Brighton went up in flames.

But the sea also yielded plentiful supplies of plaice, mackerel, herring and cod, providing that the weather allowed the boats out. By 1580 there were eighty fishing boats at Brighton and strict rules were drawn up to govern the industry. It is interesting to note that a portion of the catch's value was earmarked for the upkeep of the church, vicar and town defences.

Fierce storms in 1703 and 1705 destroyed the part of the town built below the cliffs. Indeed the outlook was so bleak that Daniel Defoe thought the whole town would soon succumb to the sea because the cost of sea defences would be more than the place was worth.

It was in the nick of time, therefore, that Dr Richard Russell started to preach about the benefits of the seawater cure. In 1783 the Prince of Wales (later the prince regent) bathed in the sea during his first visit to Brighton. Thus Brighton was launched as a place of fashion.

Not everyone was pleased, especially the fishermen who had to share the beaches with bathing machines. In 1822 the fishermen were banned from the Steine where they had been accustomed to dry their nets because fashionable folk wanted to promenade unimpeded.

New houses were built facing the sea – a major innovation at Brighton where even the Royal Pavilion did not enjoy sea views. The opening of the railway to Brighton in September 1841 also had a profound effect: it enabled Brighton to become a resort for the masses and not just for the privileged few.

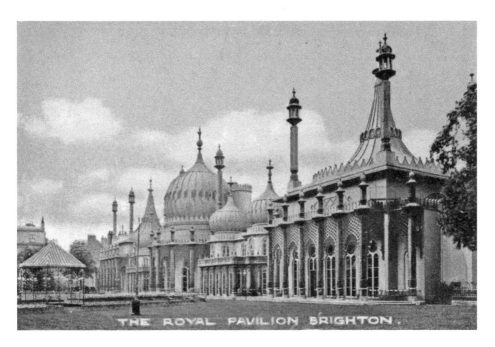

THE ROYAL PAVILION BRIGHTON.

Royal Pavilion – East Front

Today the Royal Pavilion enjoys worldwide admiration but in the nineteenth century many people regarded it as a tasteless extravagance, while Queen Victoria disliked it so much that in 1850 she sold it for £53,000 to Brighton Corporation – they did not know quite what to do with it either.

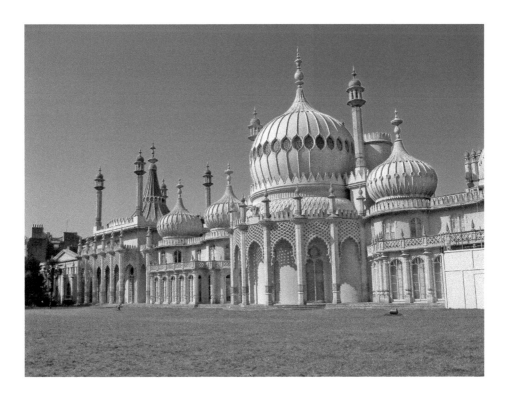

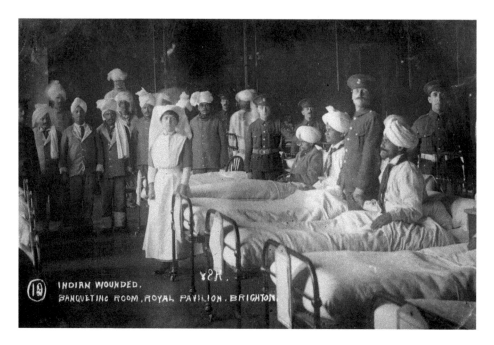

INDIAN WOUNDED.
BANQUETING ROOM, ROYAL PAVILION, BRIGHTON.

Royal Pavilion – East Front

During the First World War the Royal Pavilion became an Indian Military Hospital. There were painstaking preparations to meet the dietary requirements of different religions including nine separate kitchens and two water taps on each ward. Altogether, some 724 beds were available at the Royal Pavilion, the Dome and the Corn Exchange.

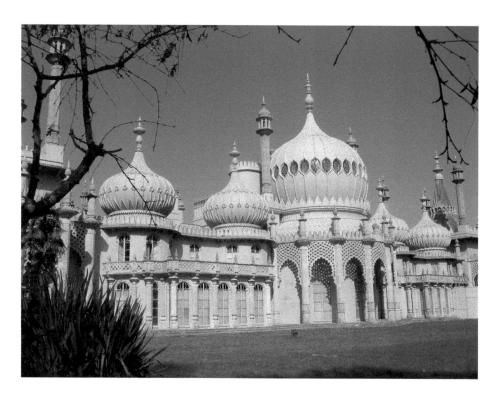

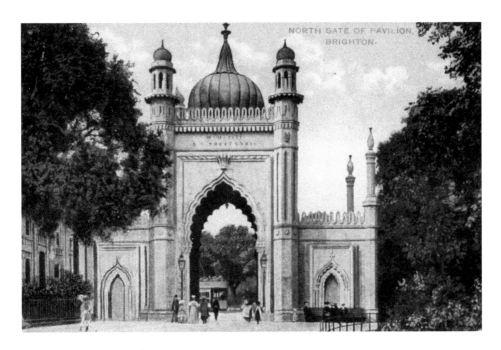

Royal Pavilion – North Gate

The Prince Regent (later George IV) planned the North Gate in 1816, but he died in 1830 and the gate was not erected until 1832. This delay was because an obstinate blacksmith with premises on the proposed site kept raising his price. The exasperated Town Commissioners then acquired them by compulsory purchase and presented them to the king.

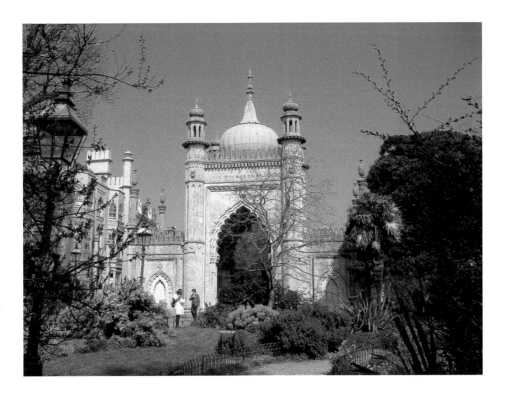

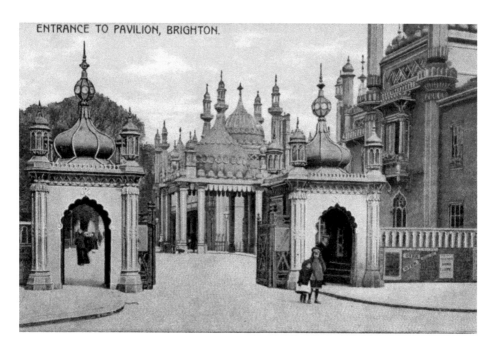

Royal Pavilion – South Gate

The original South Gate was demolished in the 1850s and replaced by the charming structures shown in the postcard. These in turn were replaced by the present gate designed by Thomas Tyrwhitt and unveiled in October 1921 by the maharajah of Patiala as a memorial to the Indian soldiers who had been nursed at the Pavilion.

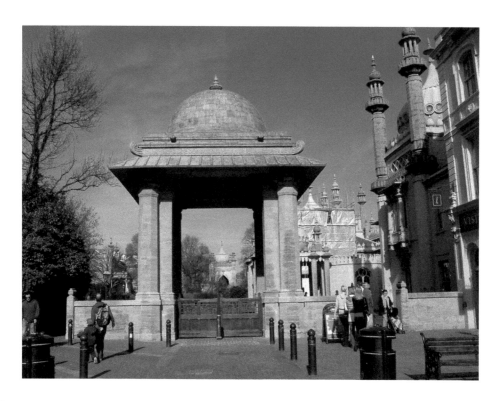

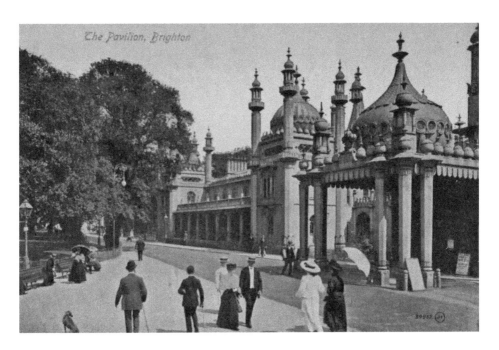

The Pavilion, Brighton

Royal Pavilion – West Front

The port-cochère was a practical addition to the palace and allowed visitors to alight from their carriages under cover and without falling over any unexpected steps. In keeping with the spirit of eastern architecture it resembled an Indian shrine.

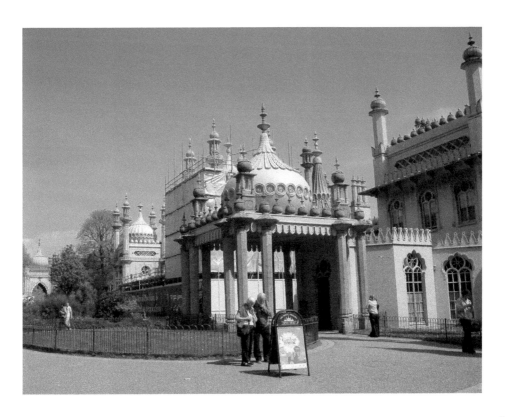

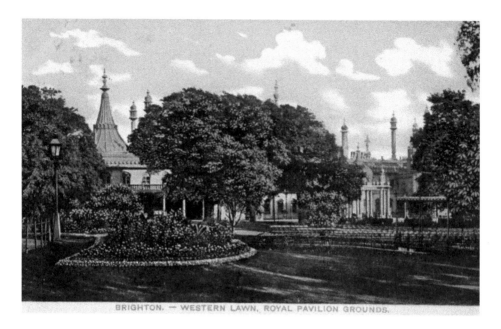

BRIGHTON. — WESTERN LAWN, ROYAL PAVILION GROUNDS.

Pavilion Gardens – West Side

The first view dates to around 1905 and shows formal bedding and chairs set out for an open-air concert – in short, the garden disregards the Pavilion and is just a municipal open space. During recent years the gardens have undergone a transformation, being restored as far as practical to John Nash's original plan. In the second photograph the large blue disc on the right was a mirror installed for the Brighton Festival.

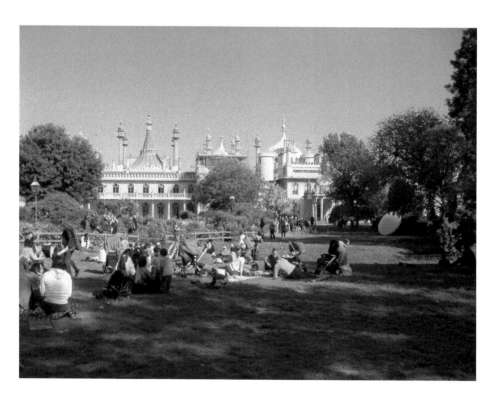

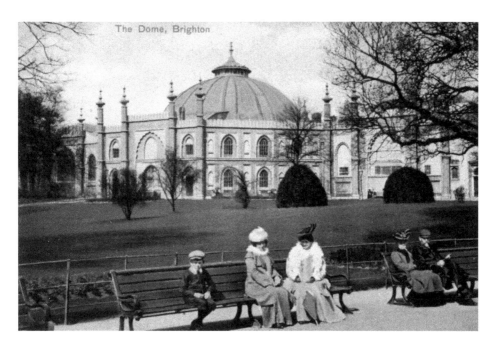

The Dome

The Dome was the first Indian-inspired building in Brighton. It was completed in 1808 and designed for the comfort of the royal horses. There were forty-one stalls arranged in a circle with twenty-two more stalls in the courtyard. Since 1867 the Dome has served as a concert hall.

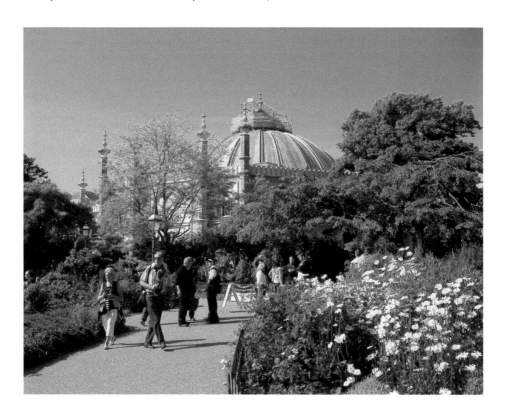

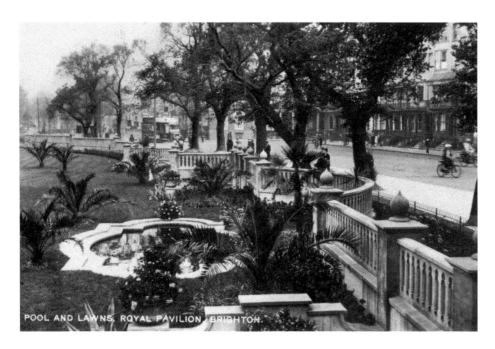

POOL AND LAWNS, ROYAL PAVILION, BRIGHTON.

Pavilion Gardens – East Side

The postcard dates from 1927 and shows the balustrade and pool constructed on the eastern side of the Pavilion in the early 1920s. The elm trees flourishing in the pavement were originally within the Pavilion boundaries. Some of them blew down in the great gale of 1987 and damaged part of the balustrade at the same time.

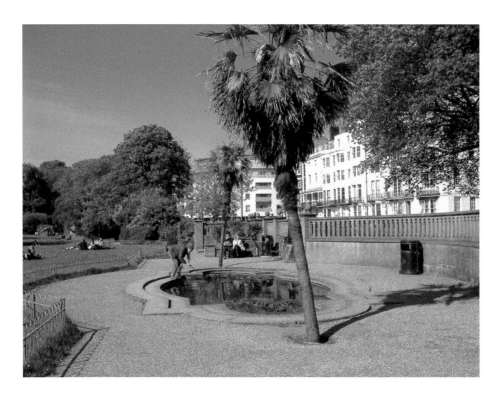

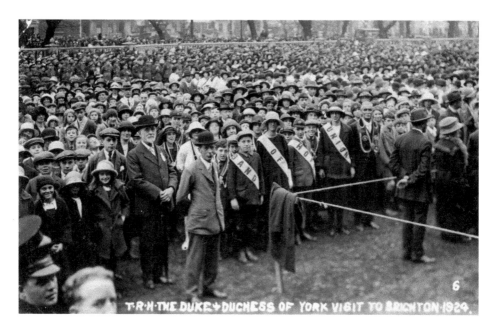

T·R·H·THE DUKE+DUCHESS OF YORK VISIT TO BRIGHTON·1924.

Awaiting a Royal Visit – 1924

A dense crowd await the arrival of the Duke and Duchess of York on 17 October 1924. They are packed into the Pavilion gardens (the balustrade can be glimpsed in the background). The photograph offers further proof of the Pavilion's lowly status at that time. The Band of Hope was a temperance organisation. In the recent view, the attractive red brick building tucked away in Prince's Street once housed Brighton Parochial Offices.

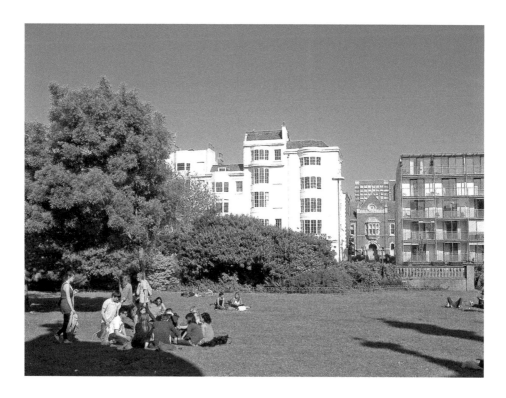

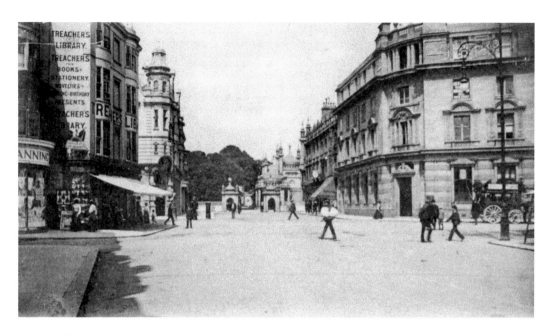

Pavilion Buildings

In this 1910 postcard Treacher's Library occupies the corner of East Street. The business survived until 1924 when Hanningtons acquired it. Some of the Pavilion Buildings were built after the 1850 purchase that resulted in the demolition of the South Gate and old offices. The recent photograph features a busker playing his violin while balancing on a tightrope.

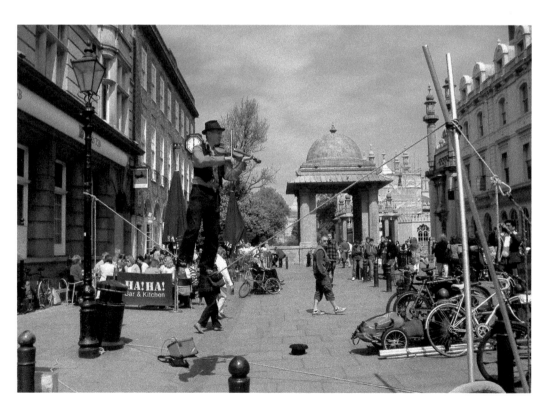

The Western Lawns, Hove

Brighton and Hove Boundary

In the first view dating from 1906 the railing on the left marks the boundary between Brighton and Hove. A tollhouse was situated on the border from 1773 until 1887 to collect a tax levied on coal brought into Brighton – the revenue being used for the upkeep of groynes. Nowadays the Peace Statue, unveiled in 1912, marks the border.

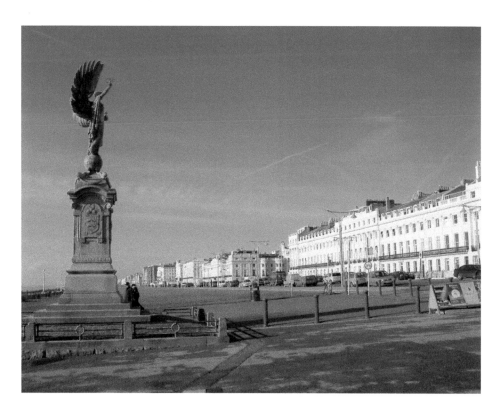

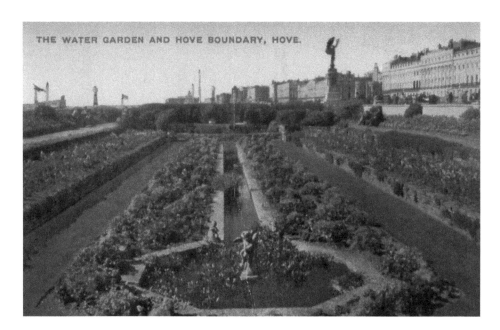

THE WATER GARDEN AND HOVE BOUNDARY, HOVE.

Sunken Garden to Petanque

The picturesque sunken garden was especially constructed to avoid salt spray and wind damage and to provide a tranquil oasis. Such a garden was too labour intensive to survive to the present time. Instead there is a flat, rolled surface on which to play petanque.

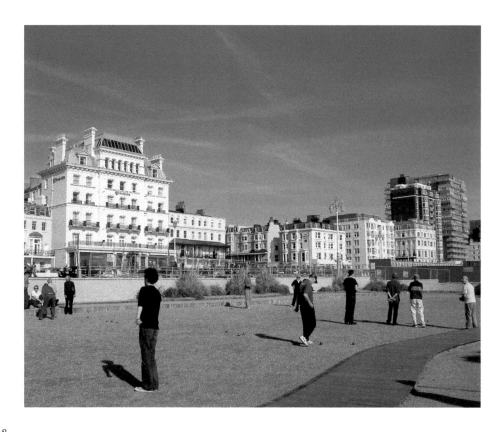

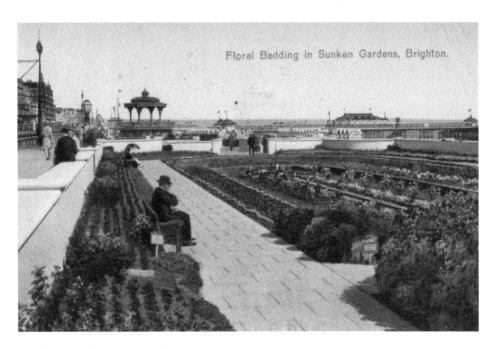

Floral Bedding in Sunken Gardens, Brighton.

Sunken Garden and Bandstand

This view of the sunken garden looks east towards the bandstand and the West Pier. The bandstand is a delightful structure erected in 1884 and decorated with filigree cast iron work. The modern view is of the continued play area for children.

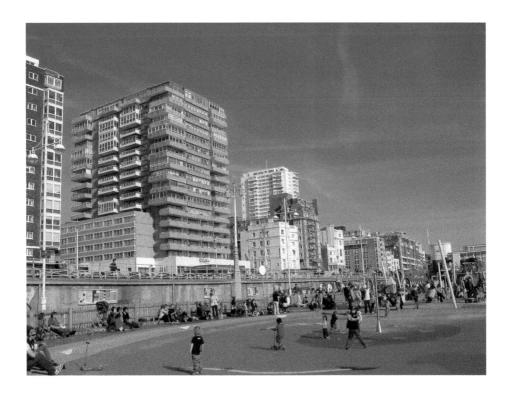

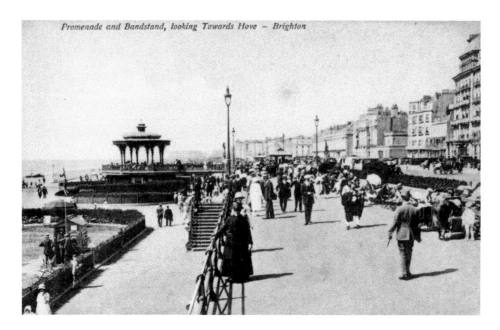

Promenade and Bandstand, looking Towards Hove – Brighton

Bandstand

In this photograph of the bandstand it looks as though a concert is in progress. The widow in the foreground belongs to another age, as the other strollers sport more modern attire. In July 2009 the refurbished bandstand was unveiled to general delight. The work cost £950,000 and included a new copper roof. The castings were grit-blasted to remove forty coats of paint, as well as rust. A band played there for the first time in thirty-five years.

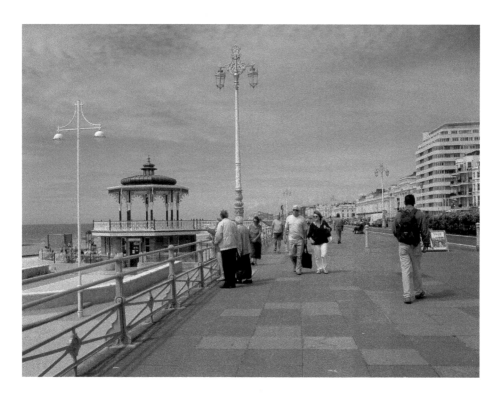

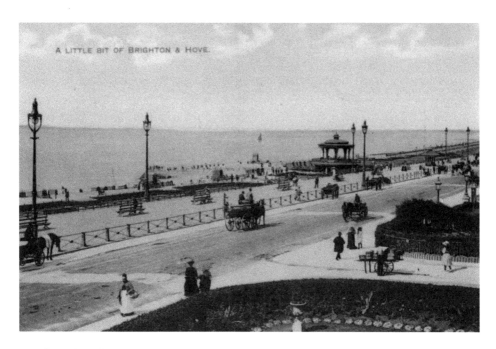

Bandstand and Lamp Standards

In 1893 Miss Ewart, the mayoress, officially switched on the electric lamp standards on King's Road. The columns stood 28ft high and some people found the glare disturbed their sleep. The second view provides a close-up of the newly restored bandstand.

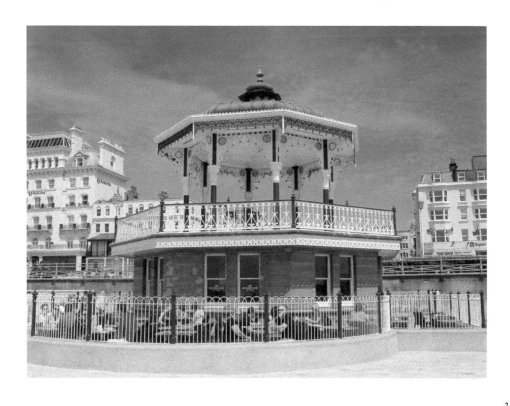

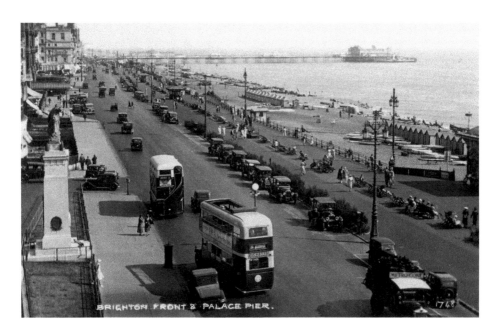

BRIGHTON FRONT & PALACE PIER.

King's Road in the 1930s

This delightful postcard from the 1930s provides a panorama of venerable vehicles and with parking space for all. Note too the buses – one with a rolled-back roof, the other with an open staircase. The modern view demonstrates the impact that Sussex Heights and Abbotts have on Regency Square.

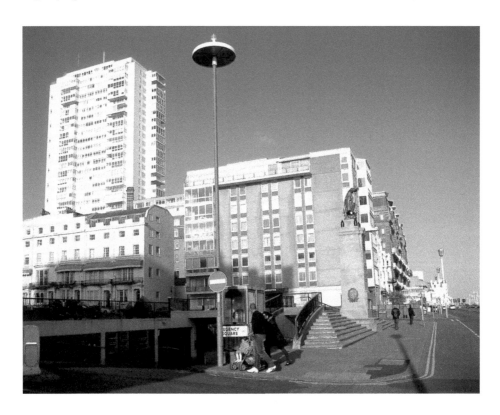

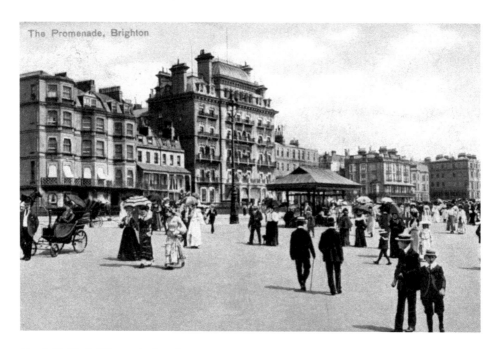

The Promenade, Brighton

Norfolk Hotel/Ramada Jarvis

The Norfolk Hotel, seen here in 1907, dates from the 1860s and was designed by Horatio Goulty. It remains one of the most elegant structures on the seafront and, fortunately, demolition plans in the 1960s were turned down. The modern view reveals the remarkable continuity in this group of buildings. The hotel is now called the Ramada Jarvis.

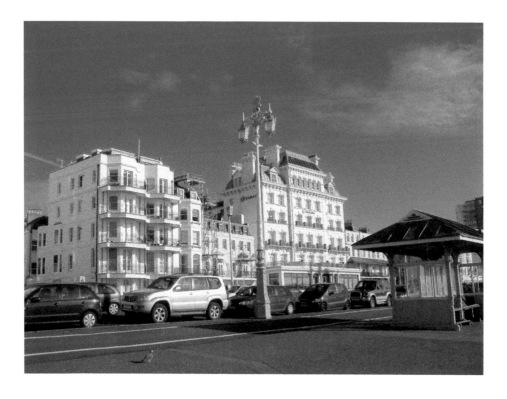

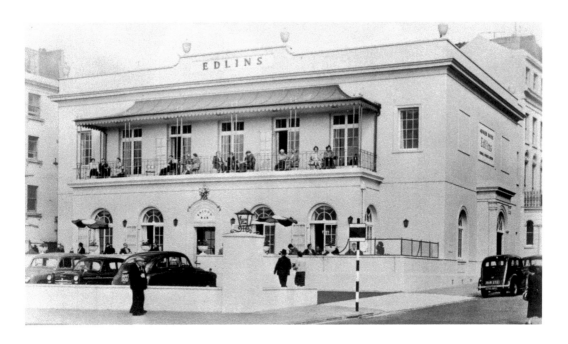

Edlin's/Kingsley Court

This gracious structure is not all it seems because it was built in the 1950s. It replaced Abinger House, the last private residence in King's Road. The Edlin family owned hotels, pubs and restaurants, and Tubby Edlin was known as Queen Mary's jester because he was one of the few actors able to make her laugh. Kingsley Court replaced it.

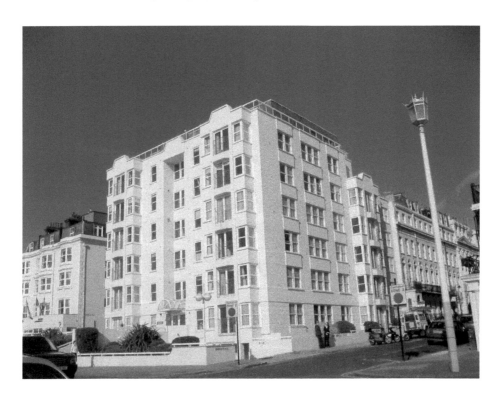

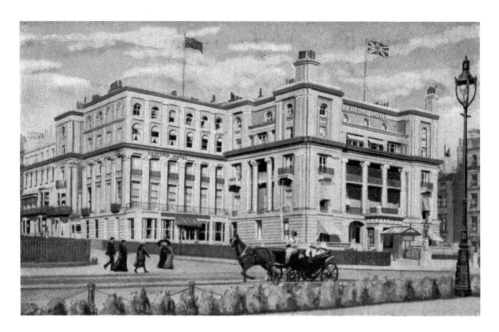

Bedford Hotel/Holiday Inn

The magnificent Bedford Hotel was designed by Thomas Cooper and opened in 1829. It was later much patronised by royalty and celebrities such as Charles Dickens and Jenny Lind. Ironically, a preservation order was under discussion when a disastrous fire broke out in April 1964. The Bedford was replaced by a monolithic structure now known as the Holiday Inn.

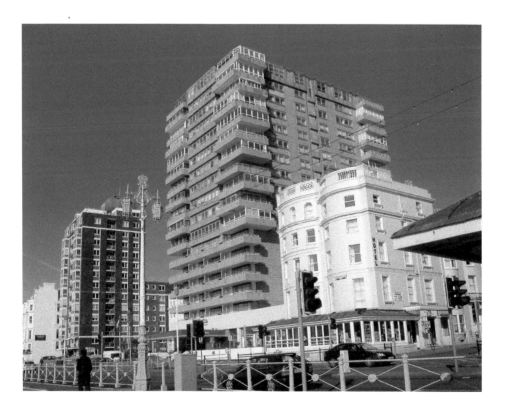

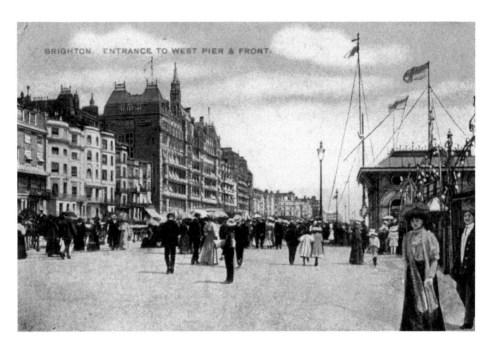

Hilton Brighton Metropole

It is remarkable how little this view has altered over the years. There is still a group of bow-fronted houses next to the towering bulk of the Metropole, as well as the West Pier kiosk. However, the little spire and attractive roofline of the Metropole have been lost.

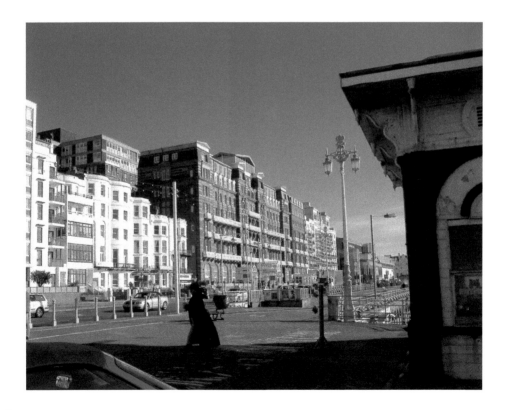

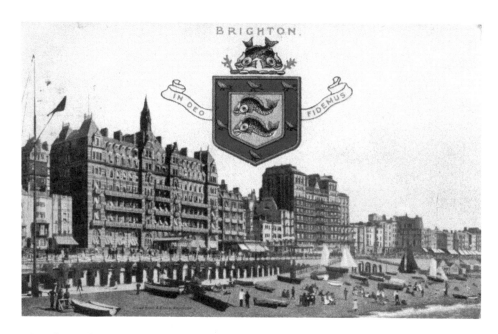

View from the West Pier

This view from 1908 was taken from the West Pier. When the Metropole was newly built in 1890, its red brick and terracotta were something of a shock to local sensibilities more accustomed to stuccoed exteriors. But it had a distinguished architect in Alfred Waterhouse. Gaiety Girls loved to stay at the Metropole. Amongst their number were Rosie Boote (who married the Marquis of Headfort) and Gertie Millar (who married the Earl of Dudley).

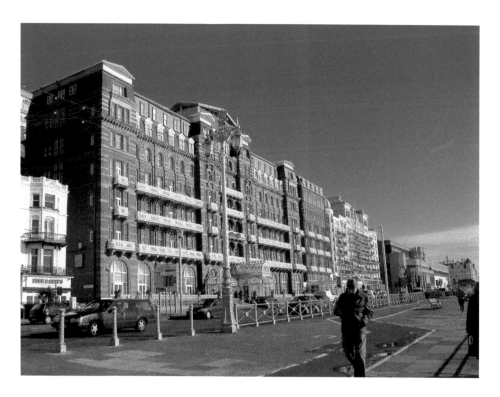

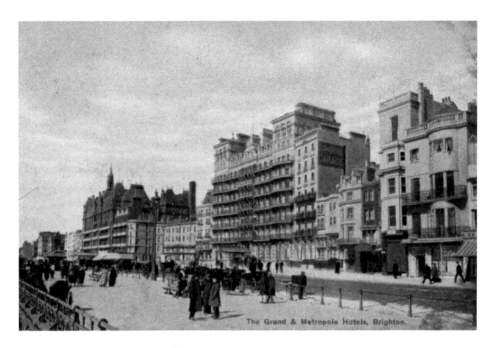

The Grand & Metropole Hotels, Brighton.

Grand Hotel/De Vere Grand

The elegant Grand Hotel was designed by J. H. Whichcord and opened in 1864. On 12 October 1984 an IRA bomb exploded in an attempt to assassinate Margaret Thatcher and her cabinet. She escaped but five people died and part of the front collapsed. De Vere Hotels, the Grand's owners, spent £10 million on rebuilding and refurbishment to exacting standards.

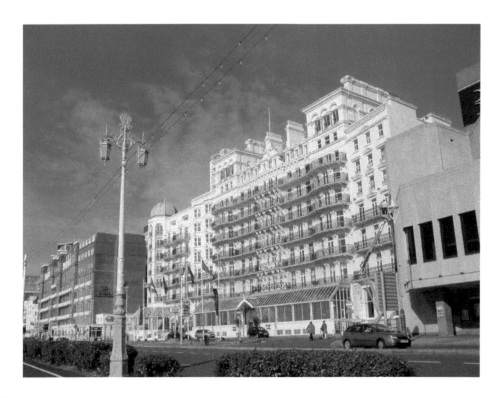

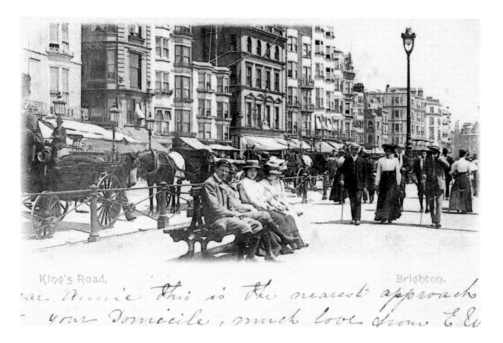

King's Road Looking East

George IV contributed £200 towards a new road along the cliff to Middle Street to replace an old track. It was named King's Road. Many of the old buildings seen here in 1908 remain but in the 1980s the buildings on the right were demolished and replaced by a new hotel, now called the Brighton Thistle.

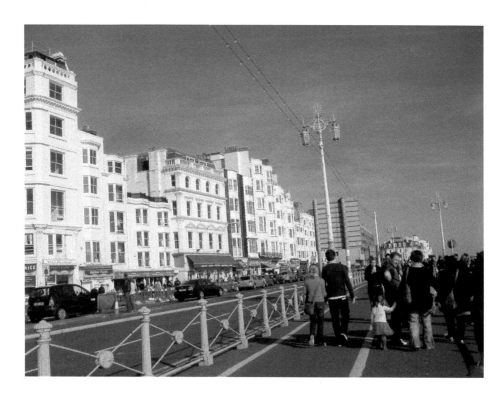

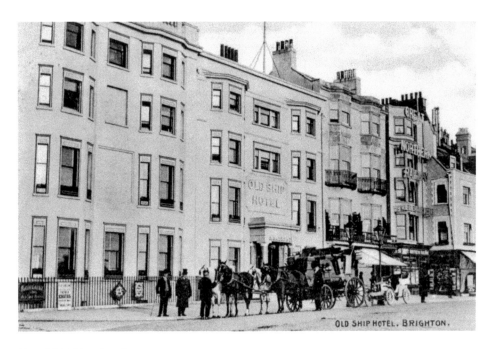

OLD SHIP HOTEL, BRIGHTON.

The Old Ship Hotel

The Old Ship is Brighton's oldest hotel and was a notable coaching inn too with the Tantivy and Old Berkeley still rolling up until the First World War. The Old Ship has a beautiful ballroom built in the 1750s with a balcony where the violinist Nicolo Paganini gave a concert in 1831. The eastern wing was added in the 1960s.

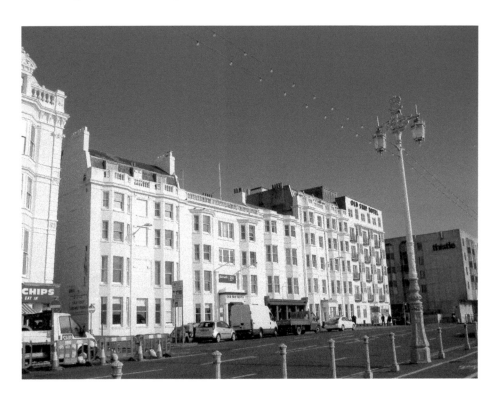

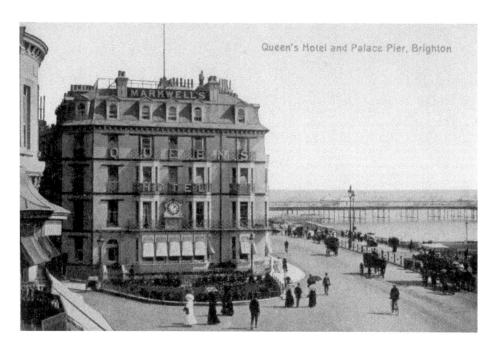

Queen's Hotel and Palace Pier, Brighton

Queen's Hotel

In the first view the name Markwell's can be seen at the top of the building and Markwell's Hotel was built in 1870. But in 1908 it was taken over by the Queen's Hotel, which had been built nearby in 1846 on the site of the Dolphin Inn. Note the bare appearance of the Palace Pier compared with the recent photograph.

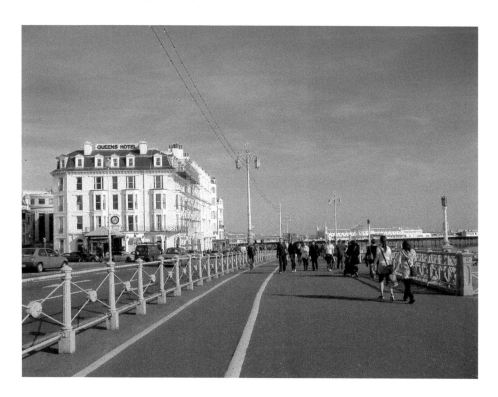

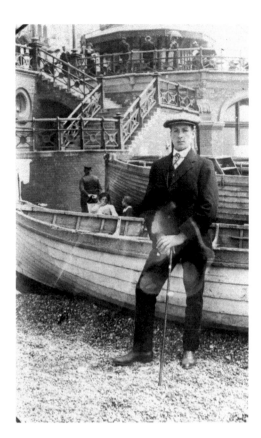

Rotunda Shelter

This young man is smartly dressed for his trip to Brighton and it is obviously a serious business posing for the photographer who would print the shot as a souvenir postcard. The rotunda shelter at the top of the steps was constructed in the 1880s and in the modern view Sheridan's Hotel can be seen in the background.

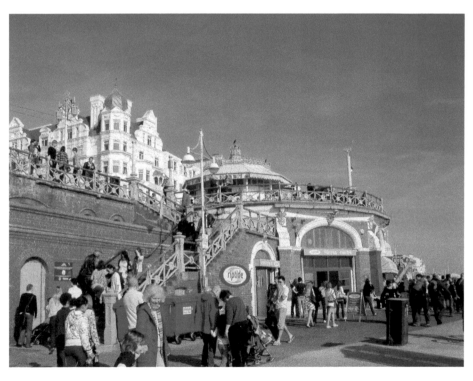

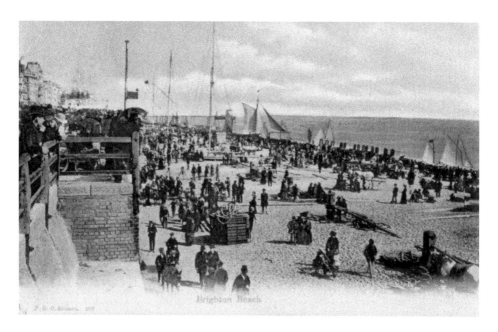

Fence and Railings

The old view is interesting because it shows how Brighton seafront once looked with its oak fence running along the promenade and over which fishermen were wont to drape their nets to dry. In 1886 work began to replace it with the present cast iron balustrade with wooden top rail. The sailing ship is probably the famous pleasure boat *Skylark*.

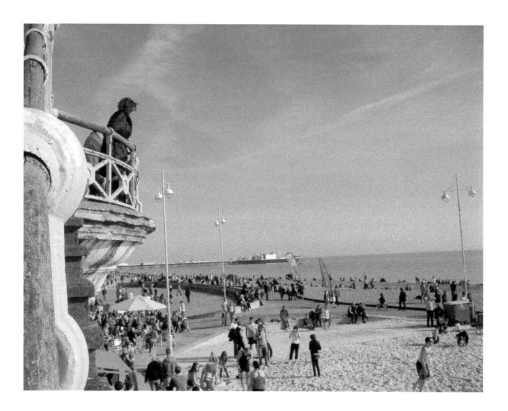

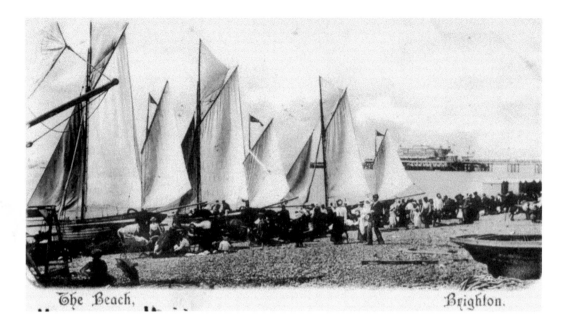

The Beach, Brighton.

Boats on the Beach
The traditional Brighton boat was the hoggie – an odd-looking vessel, very wide for its depth and with a sprit-sail rig but luggers began to replace them in the nineteenth century. The second photographs shows there are still boats on the beach although of a lighter and more streamlined frame than the old stalwarts.

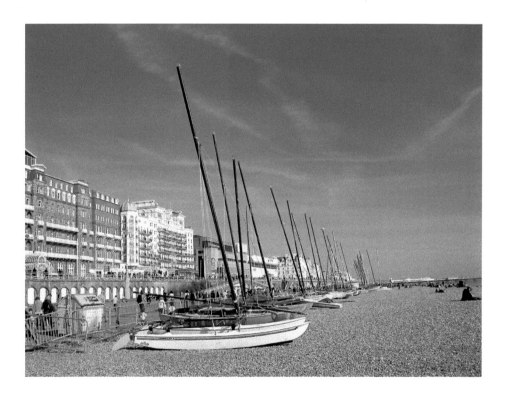

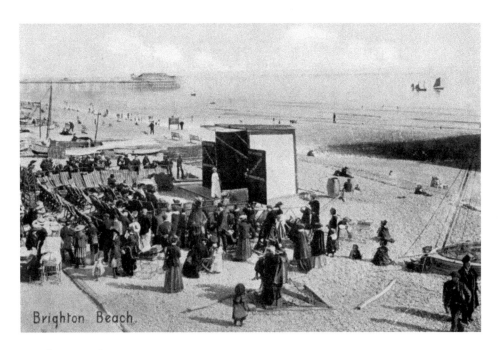

Brighton Beach.

Beach Entertainment

Various beach entertainments were a popular feature of summers past. Spectators seated in the deck chairs were expected to pay up but many people preferred to stay firmly on the path or view proceedings from the promenade above. In recent times entertainment provision has been of a more active kind.

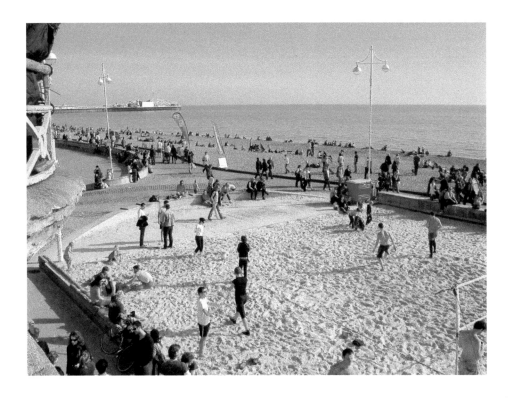

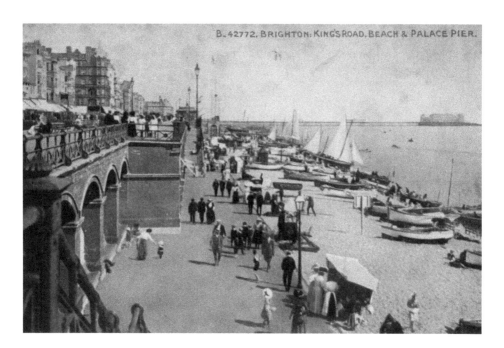

King's Road Near West Street

This view was posted in 1912 and is of interest because in the background on the left can be seen old buildings in King's Road, since demolished. The second view reveals the buildings that have replaced them – namely the Brighton Centre (opened in 1977) and Kingswest/Odeon (opened in the 1960s).

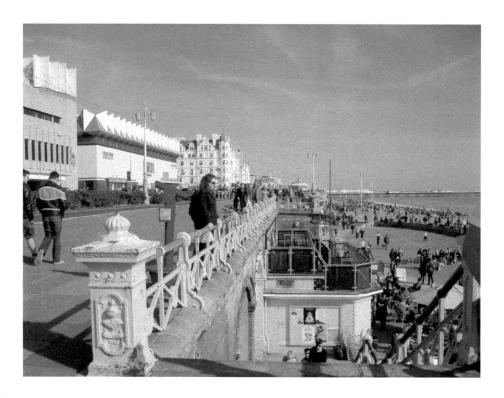

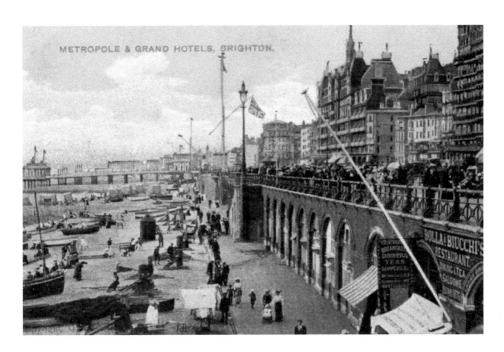

View Along the Promenade

At Bolla & Biucchi's restaurant seen on the right of the postcard, you could treat yourself to a substantial lunch for 1s in the 1890s. In the background the West Pier can be seen against the sunset. In the second view the heap of twisted metal in the sea is part of the West Pier's sad remains.

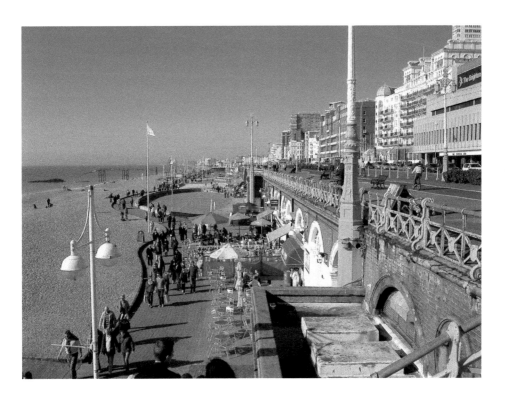

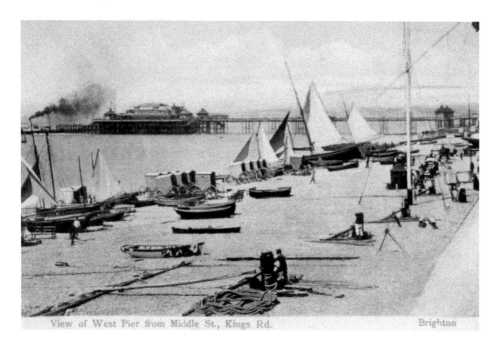

View of West Pier from Middle St., Kings Rd. Brighton

West Pier Environs

At first glance it looks as though the West Pier is on fire but it is only black smoke belching from the funnel of the paddle steamer waiting at the landing stage at the end of the pier. The second view shows a recently constructed games court with all that is left of the concert hall in the background.

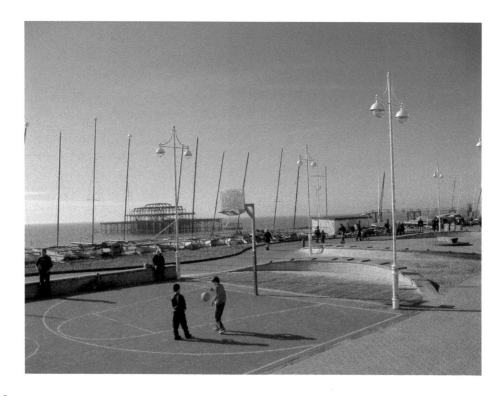

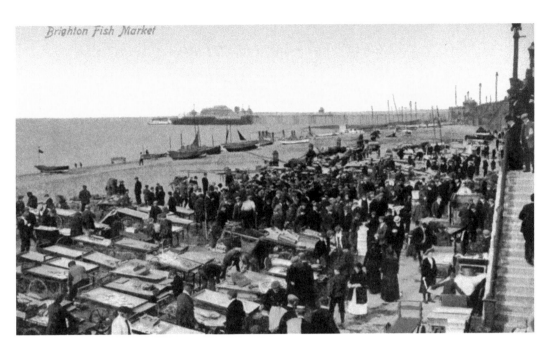

Brighton Fish Market

The Fish Market

The fish market opposite Market Street was opened in 1867. It started off in the large arch but spread out towards the sea. It was one of the sights (and smells) of Brighton. The site was closed down in 1960 and the fish market moved to Circus Street. Today in the summer months a magnificent carousel holds pride of place.

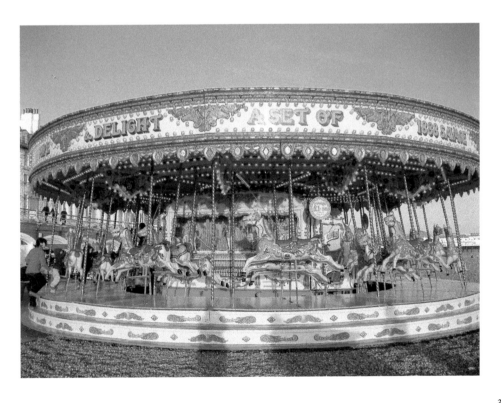

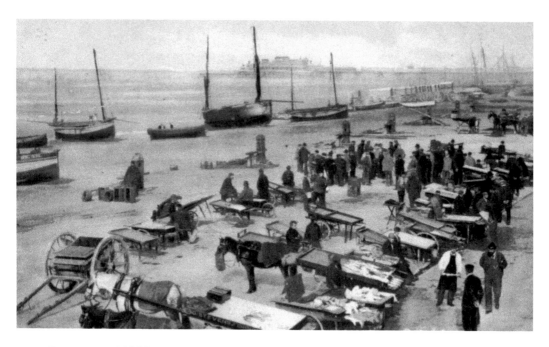

Capstans and Fishing Boats

In this postcard the line of capstans can be clearly seen. They were used to haul boats up the beach and beyond them bathing machines cater for visitors. In the second view two old fishing boats are beached outside the Fishing Museum. The one on the right belonged to G. N. Howell and was registered at Shoreham.

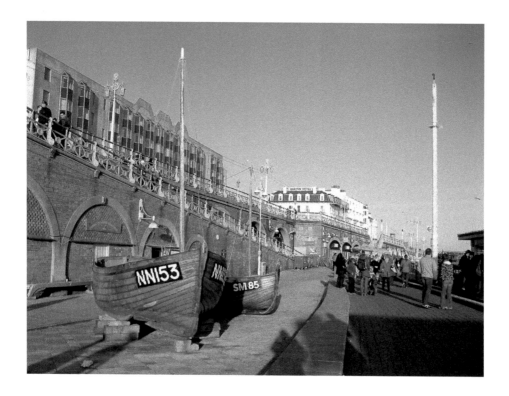

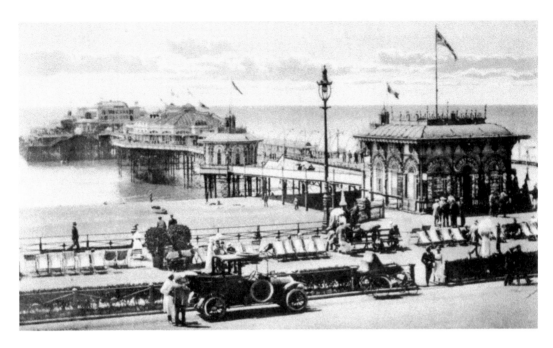

The West Pier

The West Pier opened in 1866 and was designed by Eugenius Birch. The postcard recalls it in its heyday. It closed in 1975. The pier's pavilion and concert hall were destroyed by two storms and two arson attacks within eighteen months ending in June 2004. Today the skeleton of the concert hall is an island.

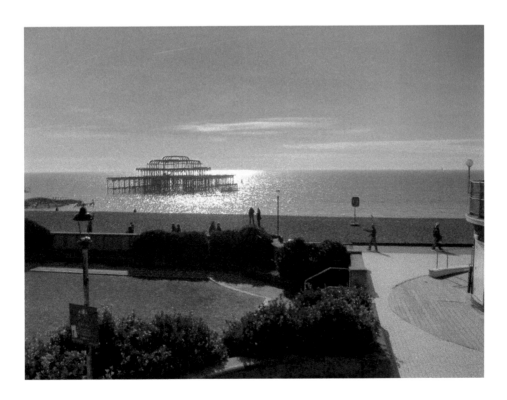

The West Pier, Brighton.

Hearty Greetings.

The West Pier

Although the West Pier is derelict it continues to attract sightseers especially those armed with a camera. It makes such a dramatic picture and there is also the dance of the starlings to watch as they return to roost. Some pieces of the pier's beautiful ironwork can be seen at the Fishing Museum.

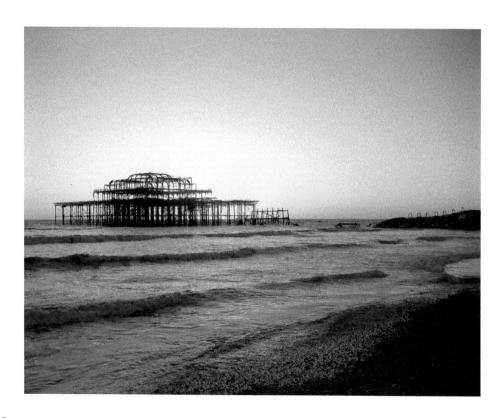

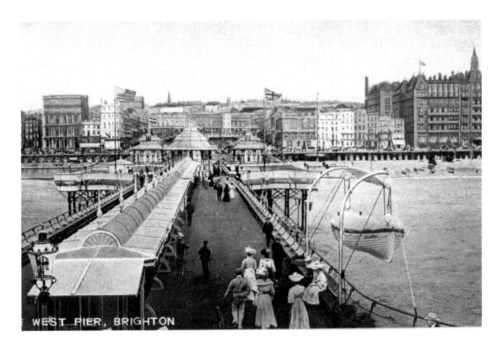

On the West Pier

One reason the West Pier proved so popular was the panorama of Brighton it provided. The pier faces Regency Square whose residents were very much against its construction in the first place. The glazed screen with seating on either side was a new idea. The equivalent modern view is dominated by Sussex Heights.

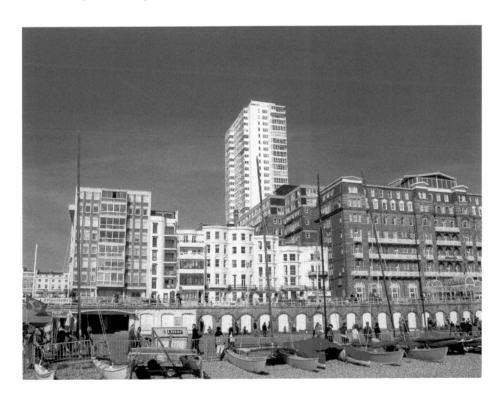

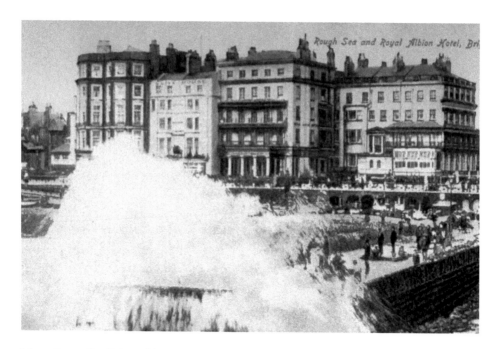

View From the Palace Pier

The view northwards from the Palace Pier has not altered very much. The Royal Albion Hotel originally occupied just the building on the east side but now incorporates the adjacent buildings too. Many celebrities have stayed there including Arnold Bennett, Hilaire Belloc and Tallulah Bankhead. During the Second World War Winston Churchill visited while bomber pilots came for rest and recuperation.

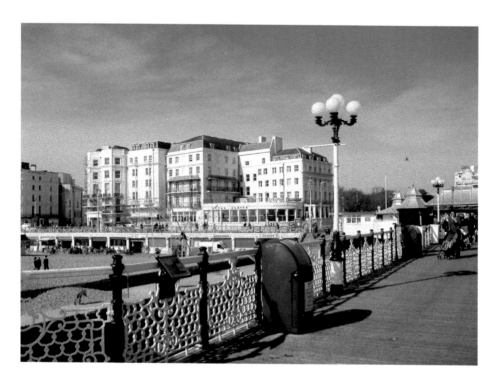

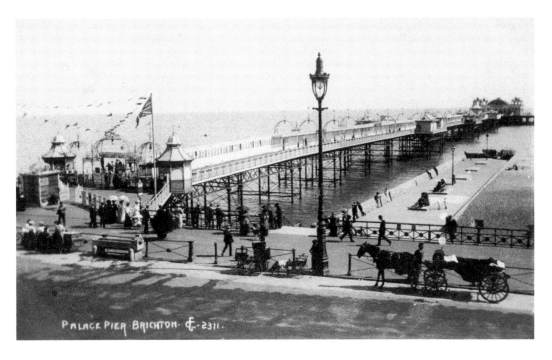

Palace Pier

The Palace Pier opened in 1899 when it was not much more than a promenade. The theatre at the sea end opened in 1901. In fact compared with the rapidity with which the Chain Pier was constructed, the Palace Pier was a long time reaching completion, work having begun in 1891.

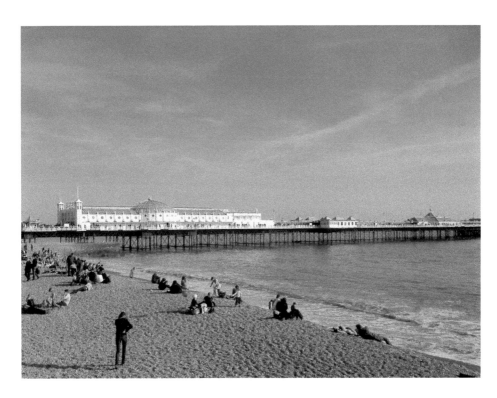

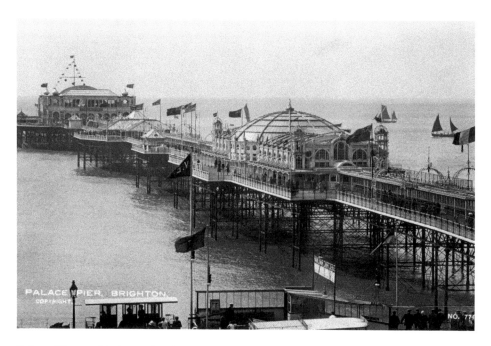

Palace Pier and Winter Gardens

This view shows the Winter Gardens that opened in 1911. It was once a restaurant enlivened by a jazz band and potted palms, then it became the Palace of Fun and it is now an amusement arcade. The pier has also changed its name, starting off as the Marine Palace and Pier, then the Palace Pier and today Brighton Pier.

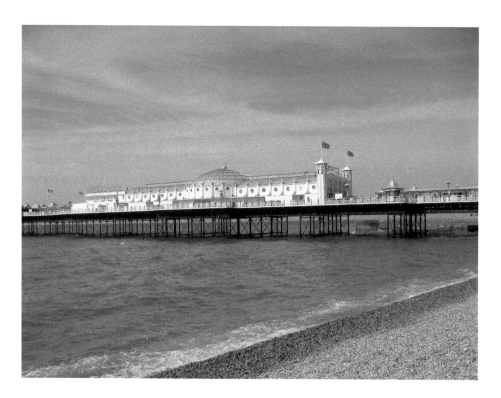

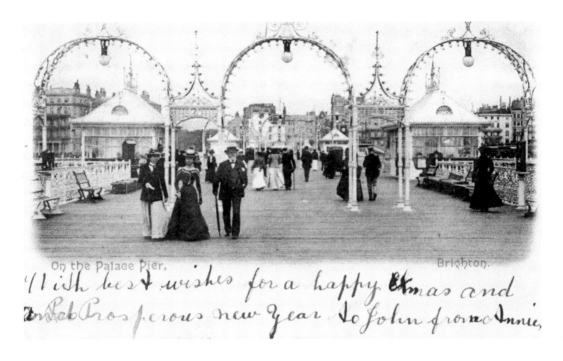

On the Palace Pier. Brighton.

With best wishes for a happy Xmas and a Prosperous new Year to John from Annie,

Palace Pier and Iron Arches

The iron arches seen in this 1902 postcard were a graceful and original feature of the Palace Pier. When the pier opened there were six groups of arches extending right up to the entrance. By 1983 there was only one complete span left. The second photograph was taken in 2009.

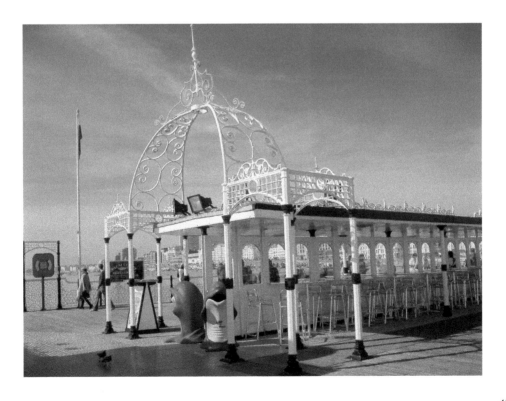

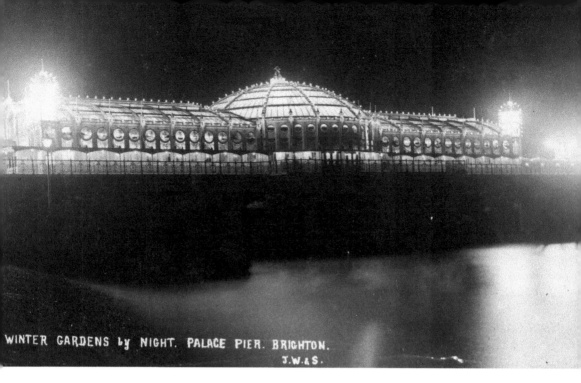

WINTER GARDENS by NIGHT. PALACE PIER. BRIGHTON.
J.W.&S.

Palace Pier at Night

The illumination of the pier at night goes back to 1906 when some 3,500 lights were installed. Naturally, there were no lights during the Second World War and after years of neglect a great deal of work had to be done before the lights came on again. A new addition is the flashing 'Brighton Pier' sign.

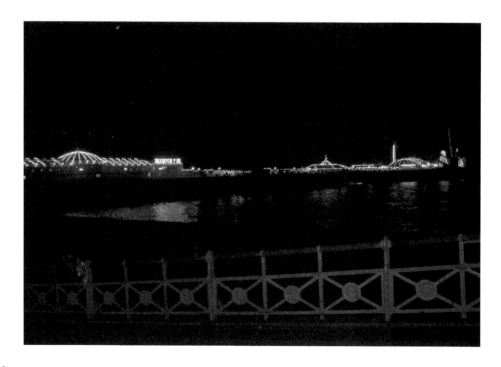

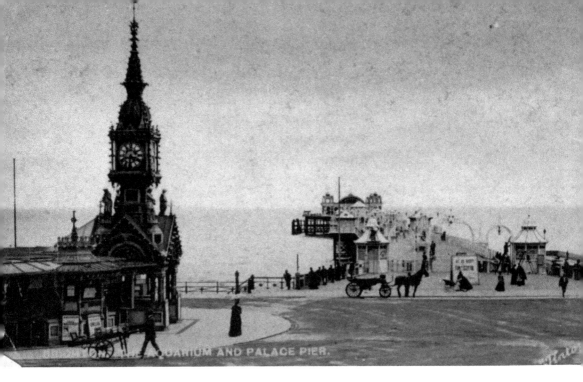

Original Entrances

Two old entrances can be seen in this 1905 postcard. On the left is the entrance to the aquarium while the Palace Pier still has its iron archways. In 1930 the pier acquired a canopied entrance with a clock tower. The second photograph was taken just as evening approached and the lights had been switched on.

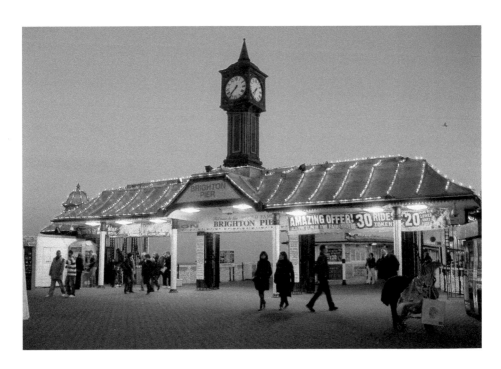

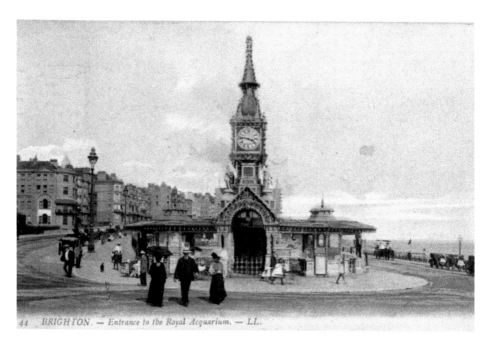

44 BRIGHTON. — Entrance to the Royal Acquarium. — LL.

Aquarium

Eugenius Birch, designer of the West Pier, was also responsible for the aquarium. It cost £130,000 to construct and within days of opening in 1872 Lewis Carroll arrived to see the new attraction. The aquarium closed in 1927 for modernisation and when it reopened in 1929 there was a new entrance.

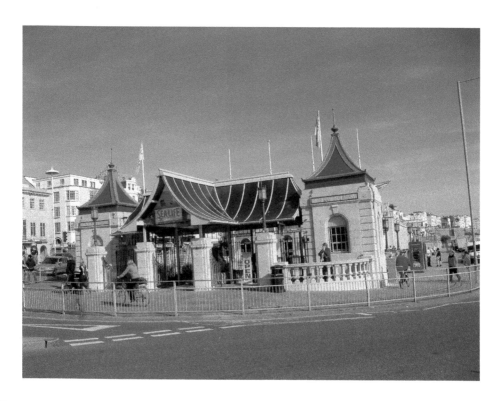

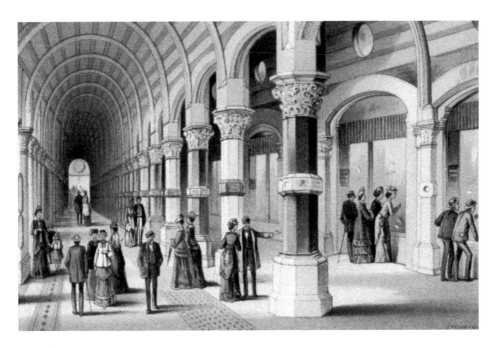

Aquarium

The opening of the aquarium provided a big splash in the national news and an illustration of the interior (somewhat similar to the first view) appeared on the front page of the *Illustrated London News*. The vaulted ceiling, fine columns and carved capitals made it seem like an underwater cathedral.

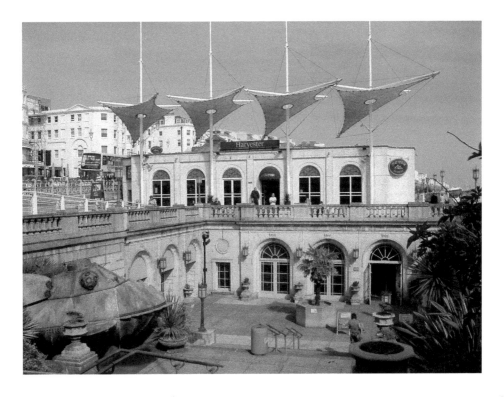

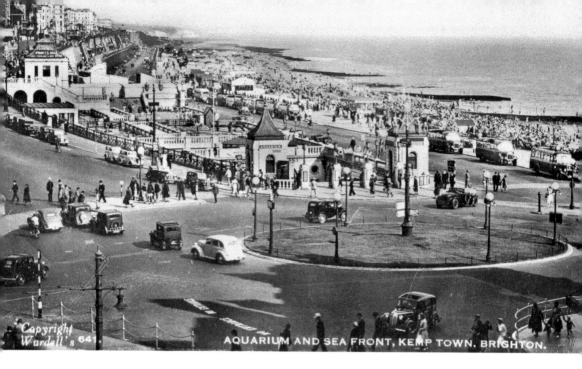

AQUARIUM AND SEA FRONT, KEMP TOWN. BRIGHTON.

Aquarium Roundabout

This fine view looking east was taken from the Royal Albion Hotel *c*. 1949. The green island is of particular interest because it is claimed to be the first roundabout in the country, being instituted in 1925. The second photograph was taken on 1 August 2009 when the roundabout was closed to traffic for a time to allow the Pride parade to pass by.

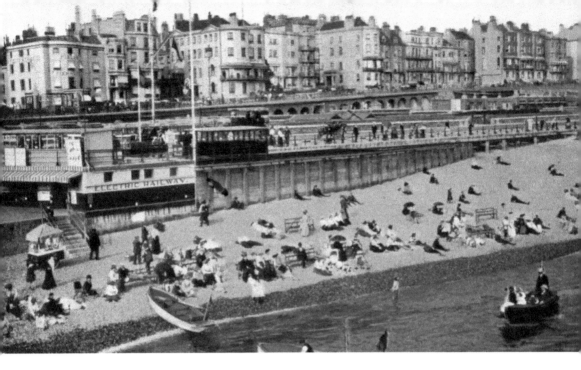

Volk's Railway

The first photograph was taken from the Palace Pier in 1908 and Volk's Railway can be seen, the track being supported by wooden piles. Designed by Magnus Volk, it was the first electric railway in Britain and opened in 1883. In those days it ran from the aquarium to the Chain Pier but in 1930 the western section was abandoned.

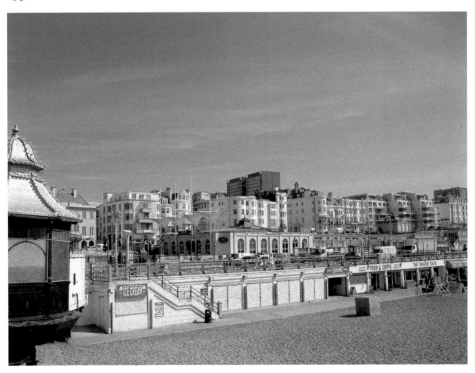

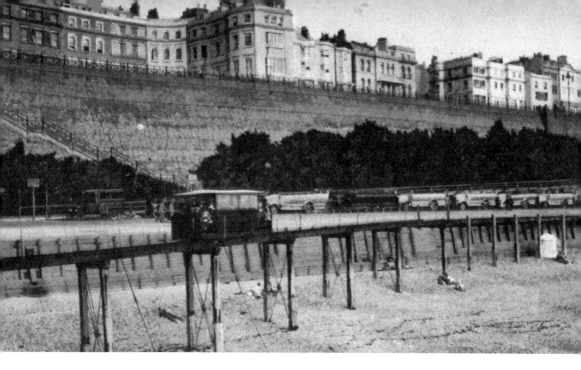

Volk's Railway

In 1933 Volk's Railway celebrated its fiftieth anniversary and this postcard dates from that era. In 1884 the track was extended to Paston Place and the 1901 extension took it to Black Rock. No doubt a modern safety expert would not be charmed by the track shown here. In 1940 Brighton Corporation took over Volk's Railway.

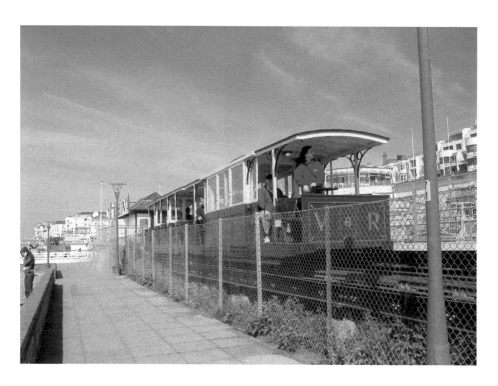

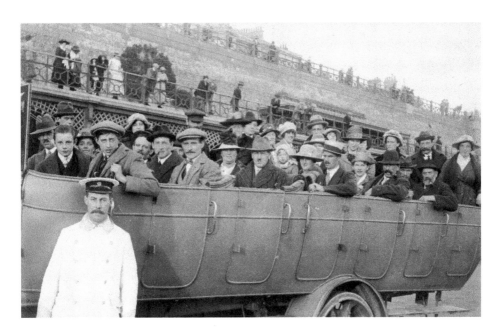

Madeira Drive

The type of charabanc seen here was a familiar sight in Brighton in the 1920s and indeed a whole line of them would park along Madeira Drive in the summer bringing day-trippers. The second view was taken on 22 March 2009 during the Pioneer Run. It starts on Epsom Downs and all motorcycles must predate 1915.

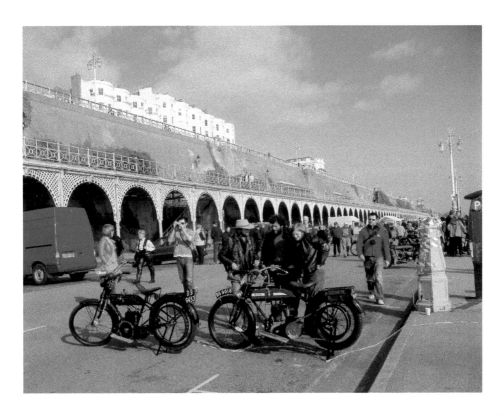

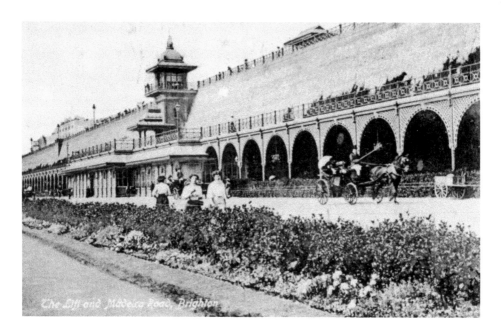

The Lift and Madeira Road, Brighton

Madeira Terrace

The Madeira Lift is part of the Madeira Terrace designed by borough engineer Philip C. Lockwood. It opened in 1890 although the whole terrace would take a further seven years to complete. The lift has been restored recently at a cost of £250,000 but at present it lacks its dolphin weather vane.

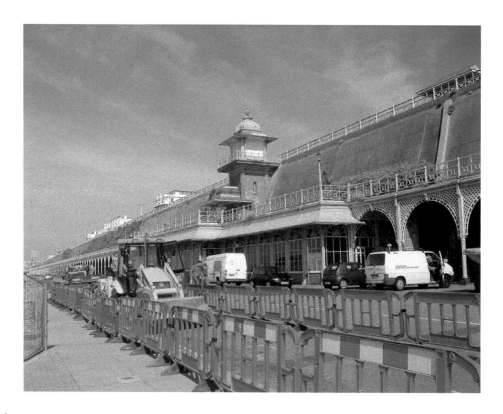

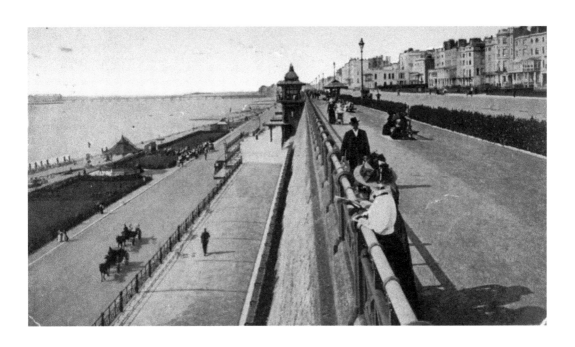

View From Marine Parade

This postcard demonstrates the grandstand view to be had from Marine Parade as you look down on two levels – Madeira Terrace and Madeira Drive. In the recent view the fish-scale tiles on the roof can be seen but the dragons at each corner are missing. The lift is a Grade II listed building.

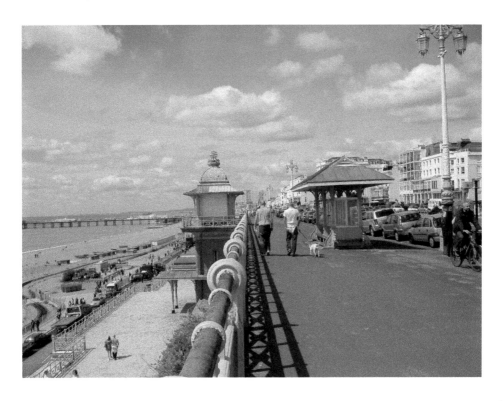

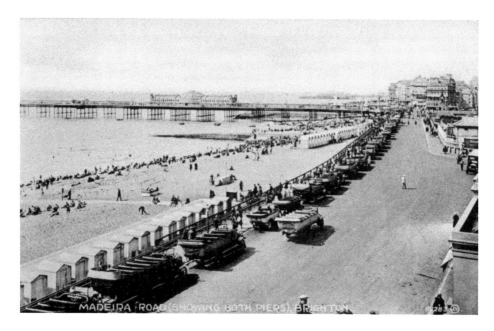

Looking Down on Madeira Drive

A fine summer's day produces a long line of charabancs on Madeira Drive in the 1920s. The men who drove such vehicles were smartly dressed in white jacket and peaked cap. The second photograph was taken on 3 May 2009 during a rally of old commercial vehicles. The furniture van is just backing into its allotted parking space.

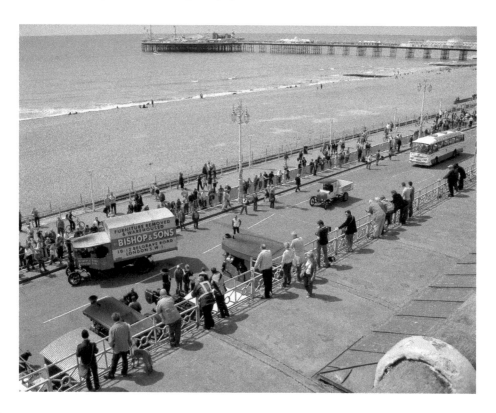

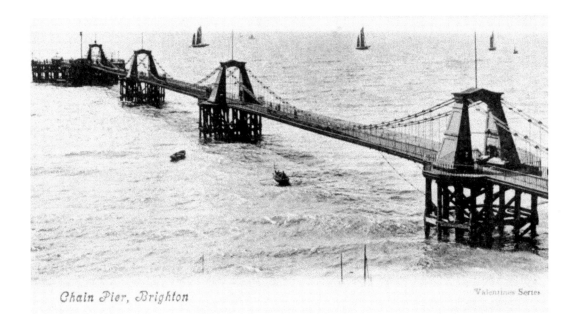

Chain Pier, Brighton

Chain Pier

The Chain Pier was built in 1828 to the design of Samuel Brown. Incredibly, it was constructed within twelve months. The massive cast iron towers weighed 15 tons each. It was such an innovation that locals did not expect it to last long – in fact it survived until 1896. From the modern viewpoint you could once have seen three piers.

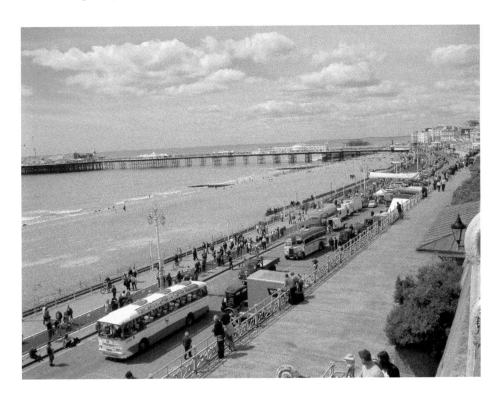

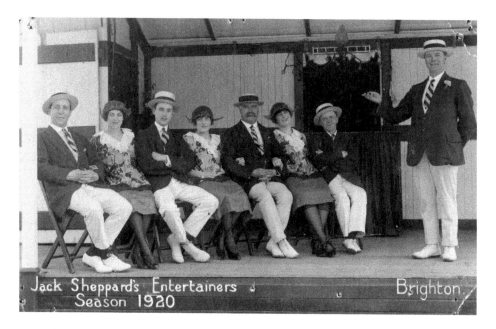

Jack Sheppard's Entertainers
Season 1920

Brighton

Outside Entertainment

Outside live entertainment has long been a Brighton feature. Jack Sheppard's group performed on a portable stage. Before the First World War they dressed in Pierrot costume and were called the Highwaymen but they had a makeover after the war. Max Miller was one of them in 1919. The second photograph is of buskers outside the Theatre Royal.

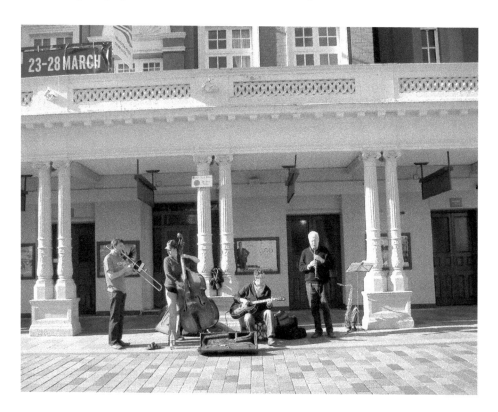

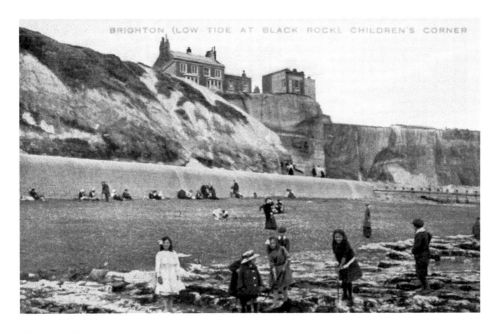

Black Rock/Marina

Black Rock at low tide was a magical place for children because there were a host of rock pools to investigate. But shoes were necessary as the rocks could be sharp. Work on the marina started in 1971 and the Queen formally opened it in 1979. The recent view shows how popular it has become.

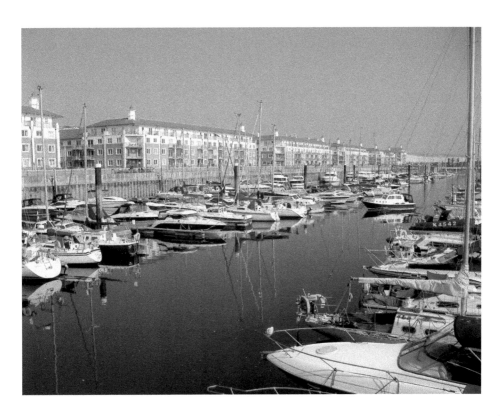

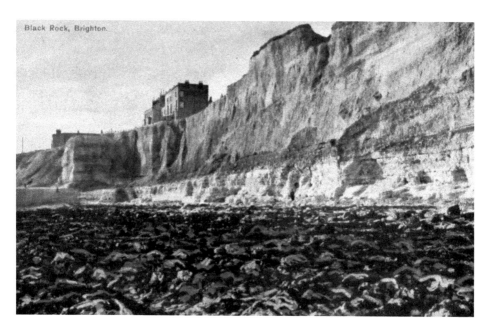

Black Rock/Marina

This postcard from 1908 may be thought bleak but it does reveal the different strata of the cliff and it is of great interest to geologists. The cliffs are still there of course but only visible from certain parts of the marina. In the second view the unusual looking vessel in the background is a floating Chinese restaurant.

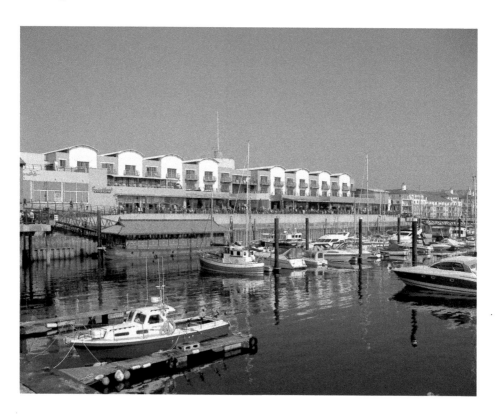

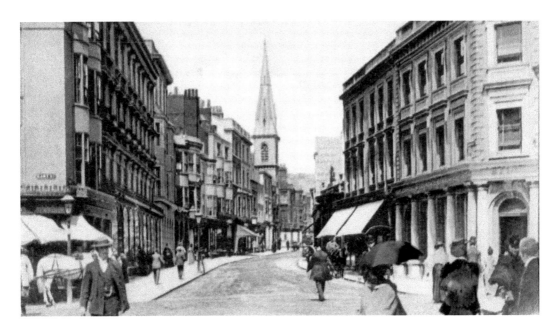

North Street

Churches are the most noticeable feature in these two views of North Street. In the earlier one the spire of the Countess of Huntingdon's church is visible. It was built in 1871 and demolished in the 1970s. In the recent photograph the Chapel Royal's tower is prominent because the building that narrowed the road was demolished in 1930.

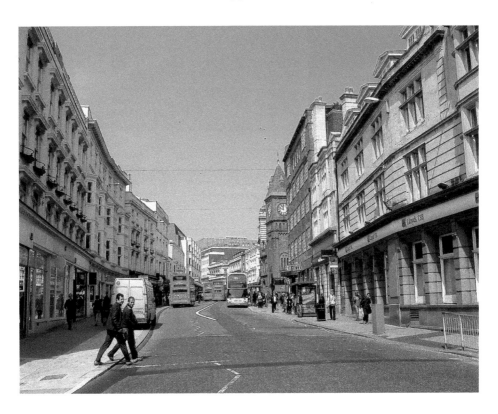

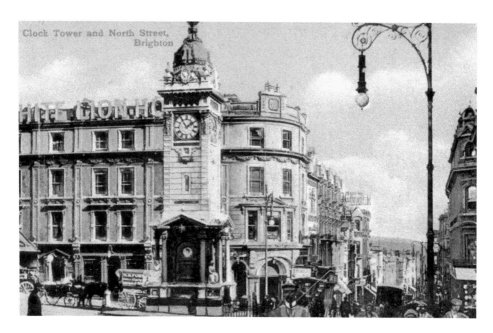

Clock Tower and North Street, Brighton

Clock Tower

The clock tower was built to commemorate Queen Victoria's Golden Jubilee. Although unique it has suffered its share of stern critics. Recently, however, some £100,000 has been spent on its refurbishment – note the re-gilded dome and ball. In the background the White Lion Hotel (built in 1874) has been replaced by Boots (built in 1979).

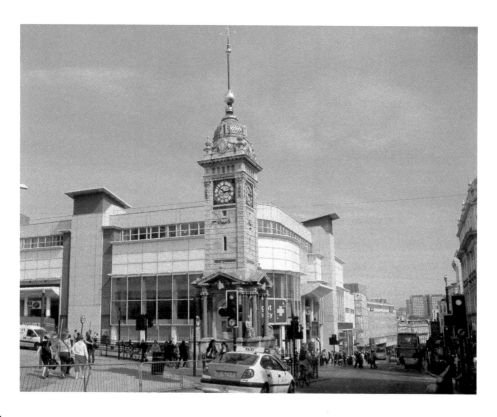

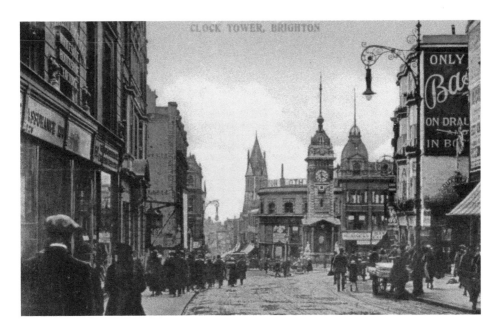

Looking Down Queen's Road

The first view looks south towards the clock tower with the spire of St Paul's in the background. On the right the large advertisement for Bass is on the wall of the Quadrant pub, recently restored after being under threat of demolition. You can see once more the ornate lettering on a gold background 'wine and spirit importer' and on the Air Street side 'Tom Bovey' the one-time proprietor.

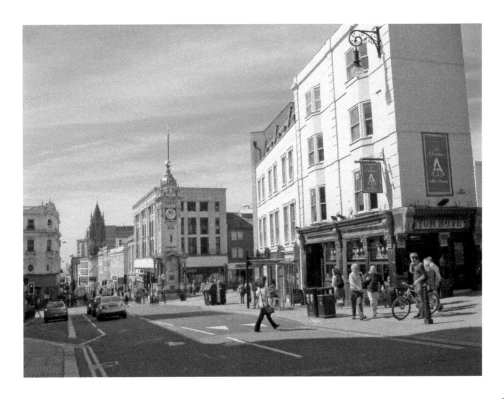

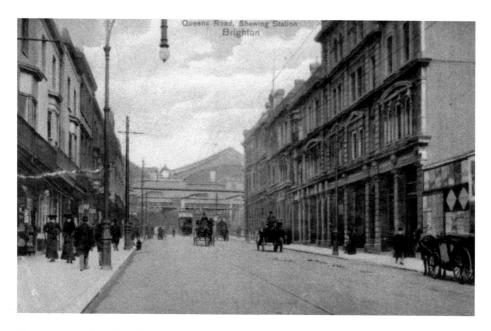

Queen's Road and Railway Station

Traffic is light in Queen's Road in 1906. David Mocatta designed the handsome station in the 1840s but the train shed roofs were built in 1883 and the canopy some twenty years later. The Mocattas had close family links with the Rothschilds, Montefiores and Goldsmids. It was an unusual move when David Mocatta decided upon a career as an architect rather than choosing the well-worn path to commerce or banking.

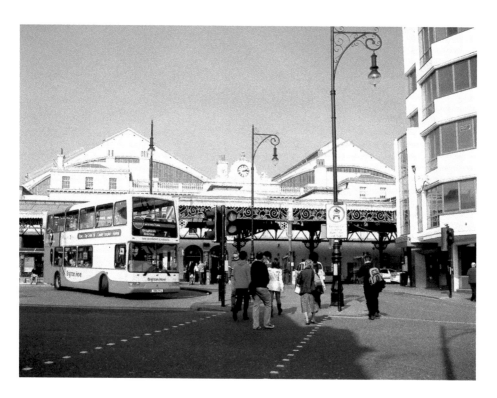

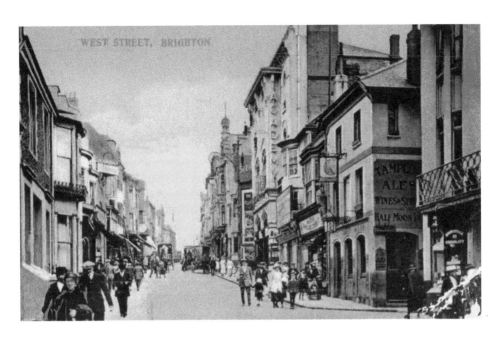

Looking up West Street

This postcard looks north up West Street and the Half Moon pub is on the corner of Boyces Street and beyond it is the Academy Cinema dating from 1911. Further on the little cupola belongs to a building with ornate plasterwork nowadays painted black and called Heist. Buildings on the west side were swept away for road widening from the 1920s onwards.

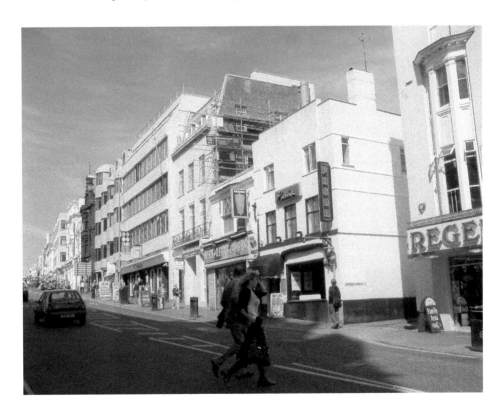

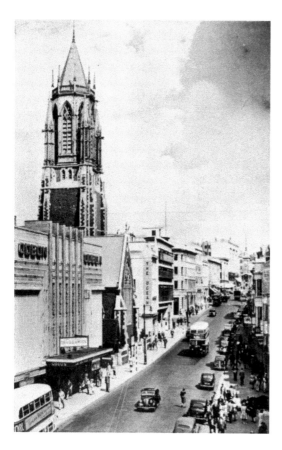

Odeon Cinema and St Paul's Church

The Odeon Cinema opened in 1931 and was demolished in 1990 although the building has been standing empty for some years previously. Fortunately St Paul's church was not affected by road widening because it had been built in the 1840s already set back. R. C. Carpenter designed the church but it was his son who added the octagonal lantern in the 1870s.

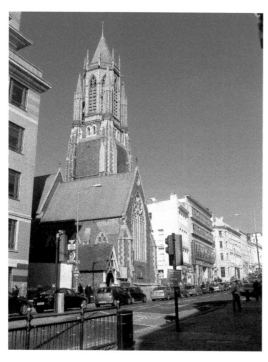

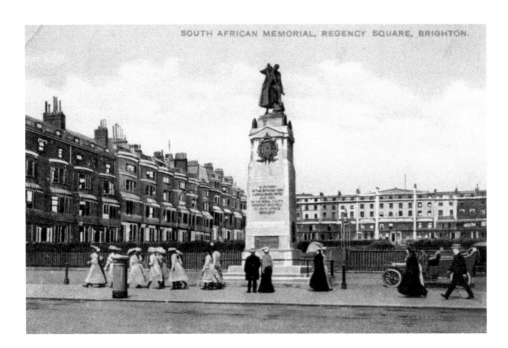

Regency Square

Regency Square was built between 1818 and 1828. It was a genteel area and you can imagine the general uproar when the West Pier was built opposite to it. Residents claimed the kiosks ruined their sea views and besides the pier was so dreadfully popular that on a fine Sunday as many as 10,000 visitors could be expected.

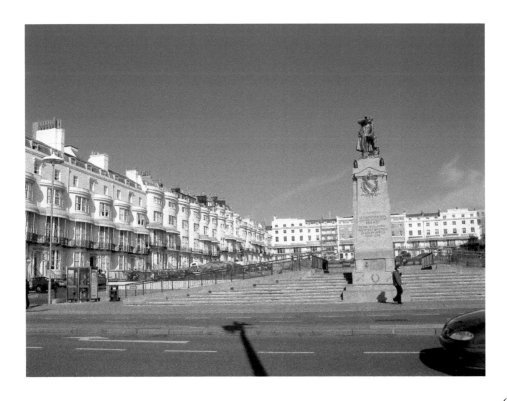

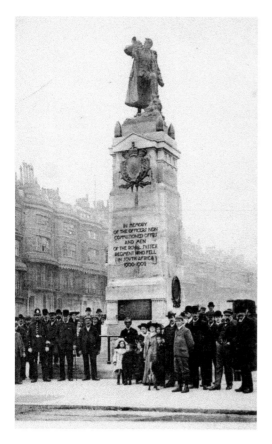

Regency Square War Memorial

On 29 October 1904 the Marquess of Abergavenny unveiled the war memorial devoted to the 152 soldiers of the Royal Sussex Regiment who died in the Boer War. The figure of the sergeant sounding the charge was based on events at Doornkop. The battles of Quebec and Louisberg (1759), Egypt (1880s) and two World Wars are also remembered. The memorial was renovated in 2008 but unfortunately paint soon started flaking off and in June 2009 scaffolding again went up.

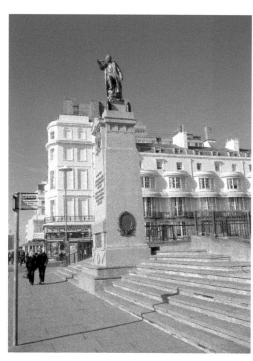

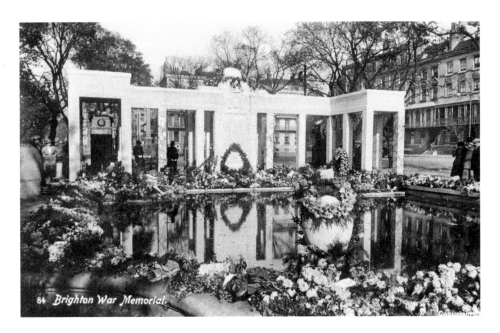

84 Brighton War Memorial.

Old Steine War Memorial

The war memorial in the Old Steine was designed by Sir John Simpson and unveiled by Earl Beatty on 7 October 1922. In order to provide space for the memorial, the statue of George IV (paid for by public subscription) was unceremoniously carted off to a new site near the Pavilion. In the second photograph Al the busker provides some music.

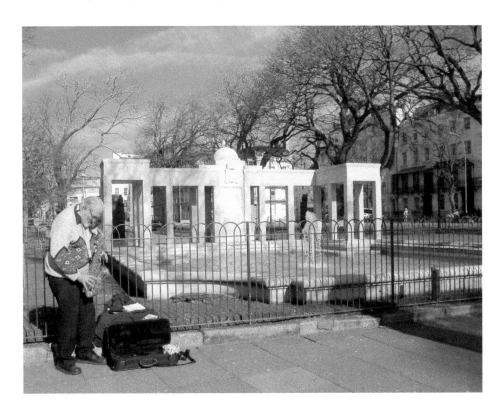

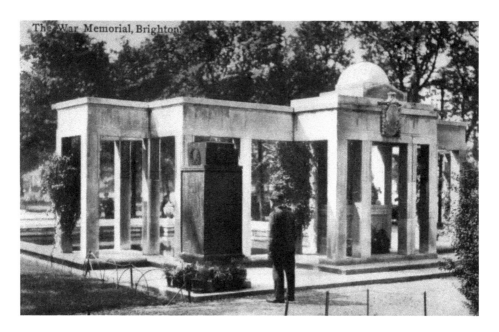
The War Memorial, Brighton

Old Steine War Memorial

The design was supposed to resemble a Roman water garden. Still water provides tranquil reflections but it also goes stagnant quickly and this is why a small fountain has since been added. It may seem odd that postcards of a war memorial were produced but few families remained untouched by the dreadful losses of the First World War.

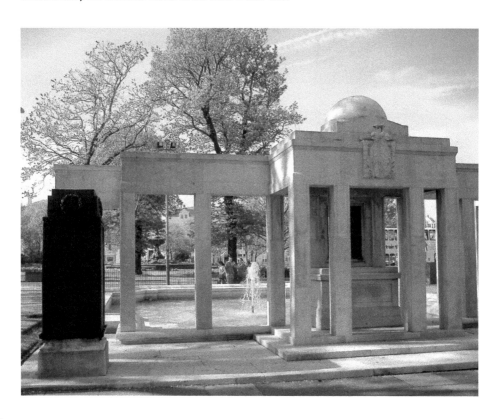

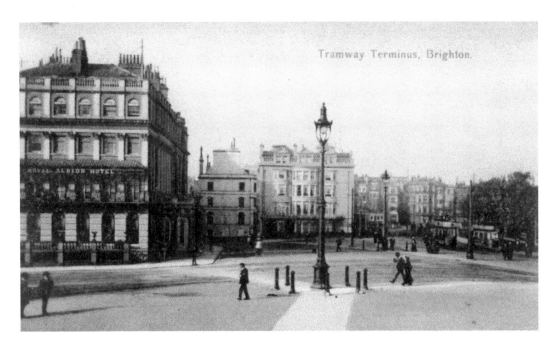

Tramway Terminus, Brighton.

Old Steine and Trams

The postcard was sent in 1908 with the following message. 'This morning I am working these cars very near the school I spent two miserable years and makes me think of resurrection pie and cabbage water they called tea and the boiled pudding and treacle that we called putty and varnish. Ah, but they were happy days.'

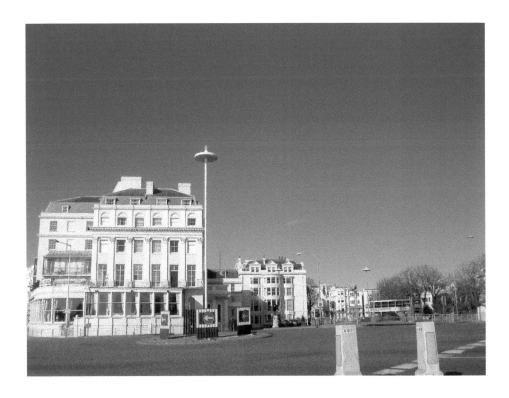

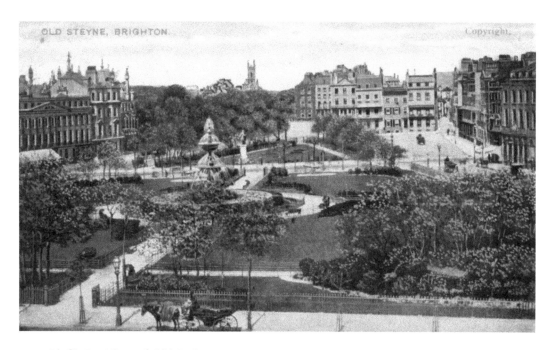

Bird's-Eye View of Old Steine

The first view of the Old Steine was taken from the Royal York Hotel. The four houses facing south were called the Blues and the Buffs because they were painted in the political colours of the Whig Party. George IV's statue is in its original position. The recent view was taken from the Royal Albion Hotel and the white marquee was erected for the Brighton Festival.

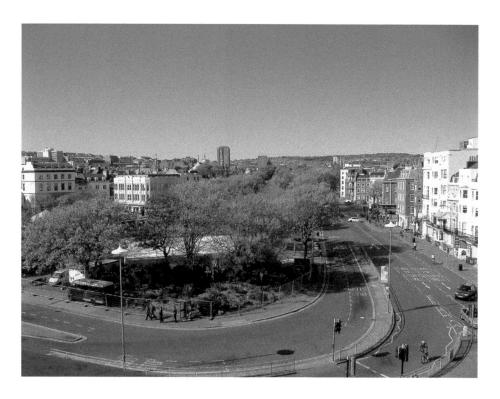

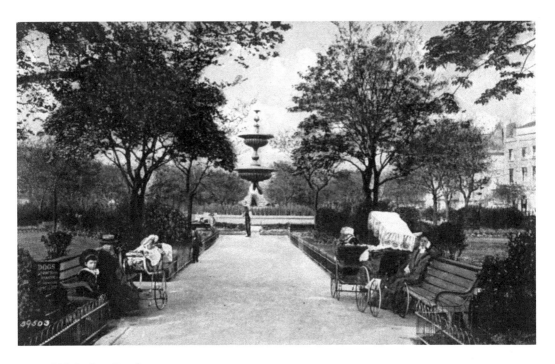

Old Steine Gardens

The postcard displays some splendid perambulators and a little boy in a sailor suit. It is possible the fountain holds reminders of ancient times – namely Sarsen stones set at the base. They were discovered in 1823 by workmen laying gas pipes in the Steine. Tradition holds they once formed a stone circle.

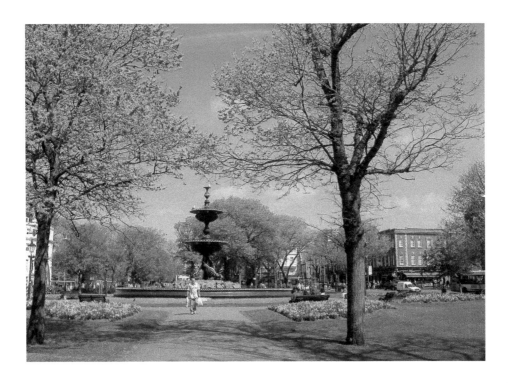

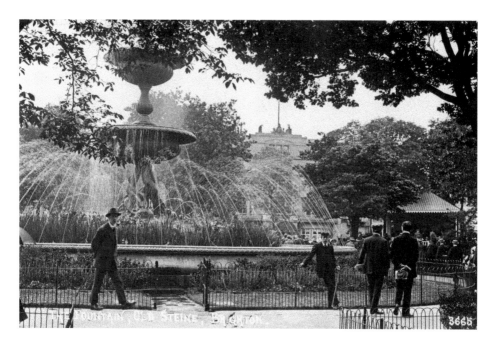

Victoria Fountain

The fountain was designed by A. H. Wilds and unveiled on Queen Victoria's birthday 25 May 1846. The structure rises to a height of 32ft. The view from the 1920s reveals a more prolific fountain than you would see today with jets around the rim. When the fountain was recently restored it reverted to its original design.

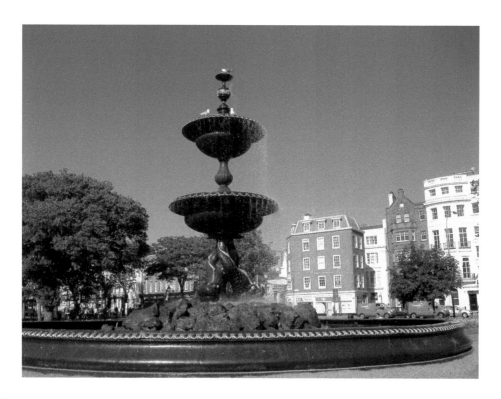

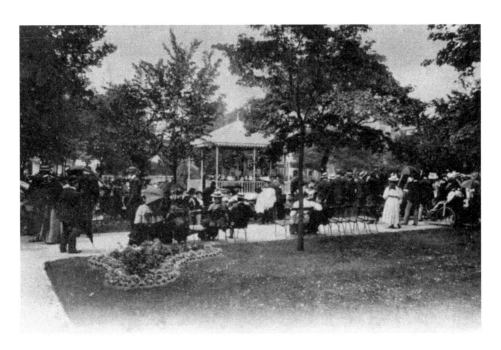

Old Steine Gardens

This postcard dating from 1909 shows the bandstand situated in the south-west corner of the Old Steine. It seems that in Edwardian summers you were never far away from a live band playing, preferably a smart military one. In the recent view the café with outside seating proves popular – the structure was once a bus shelter.

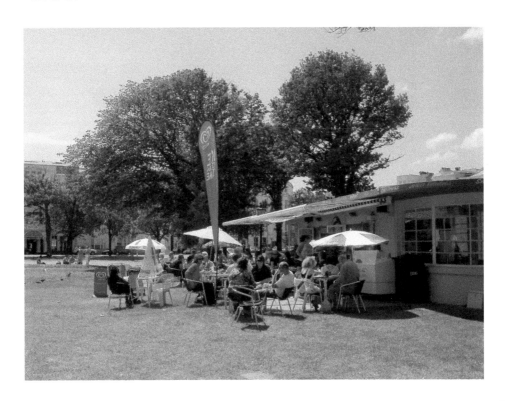

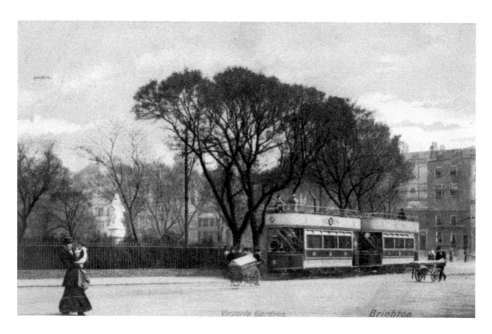

Tram Terminus

Trams ran through Brighton for thirty-eight years. They were double-decker and open-topped and inside passengers sat facing each other. The original tram terminus was at the foot of Victoria Gardens but in 1903 the terminus moved to the foot of the Old Steine. Today buses hurry past the site of the old terminus.

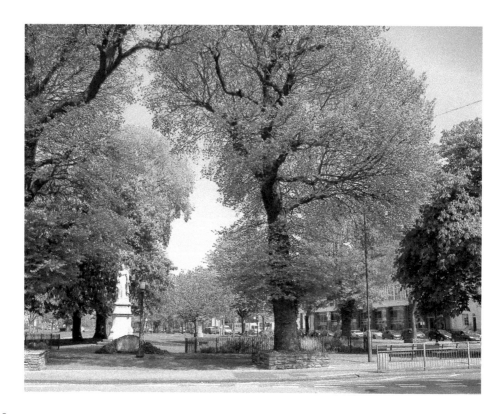

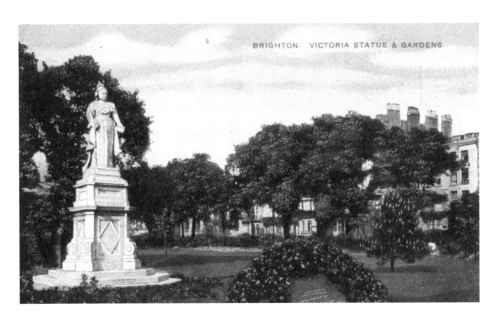

Queen Victoria's Statue

The marble statue of Queen Victoria still presides over the gardens named after her although the top piece of her crown appears to be missing. Formerly, the gardens were restricted to subscribers but to celebrate the queen's Diamond Jubilee in 1897 the mayor of Brighton Sir John Blaker opened them to the general public.

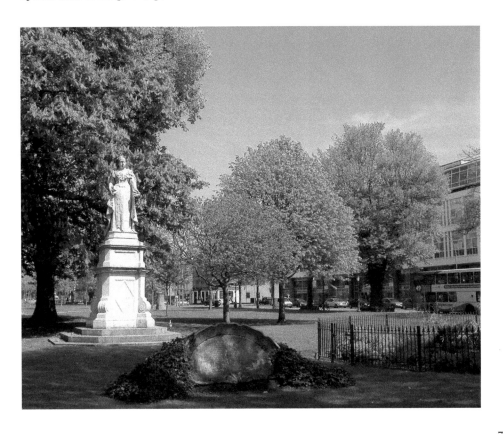

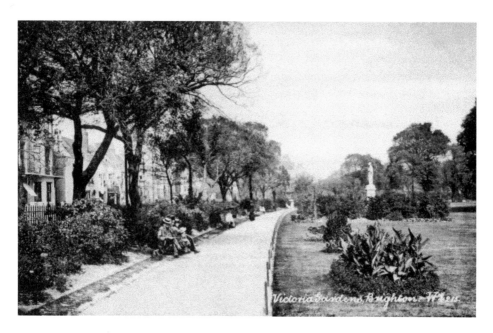

Victoria Gardens

As can be seen in the postcard dating from 1910 Victoria Gardens was once enclosed by iron railings. Sir Edward Sassoon donated the statue. The modern view is of the splendid Tudor-inspired King and Queen pub built in the 1930s. The old bow-fronted King and Queen can be glimpsed through the trees in the first photograph.

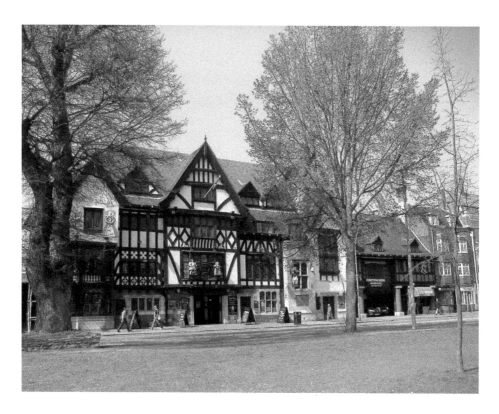

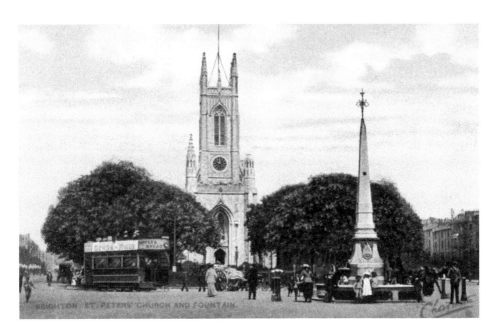

St Peter's Church From the South

The drinking fountain dates from 1871 but the obelisk seems truncated by the loss of its finial. Regrettably, metal thieves stole the bronze plaque in February 2009. St Peter's church was constructed in the 1820s and designed by Charles Barry, later famous for his Houses of Parliament. St Peter's was a very expensive church, costing over £20,000 to build.

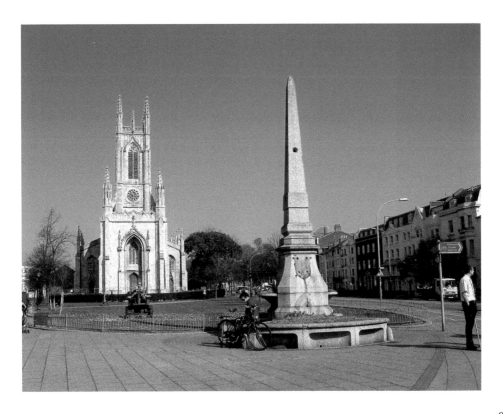

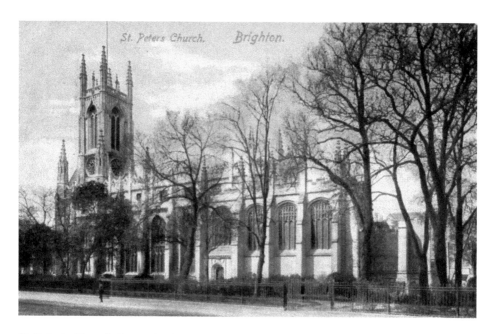

St Peter's Church From the East

The postcard presents a flattering view of St Peter's. But an extension made of Sussex sandstone blended badly with the original Portland stone. Lately, the church has fallen on hard times because of the cost of keeping the building in repair, the responsibility of a small congregation. However, in 2009 came news that Holy Trinity, Brompton, would come to the rescue.

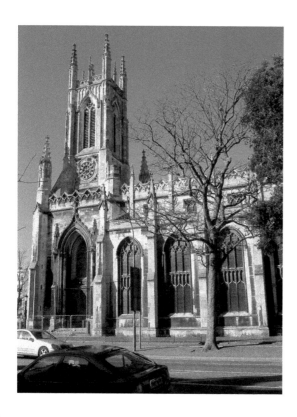

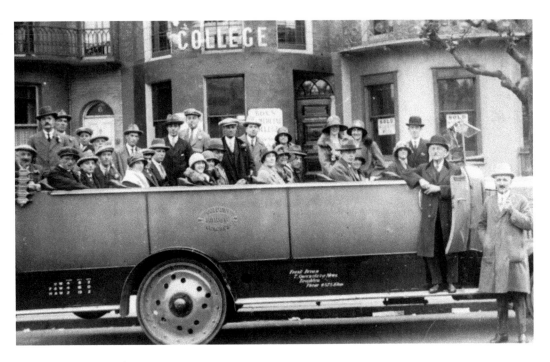

St George's Place

Box's Commercial College was situated at 7 St George's Place and was founded in the 1890s. The college's slogan was 'Be Businesslike.' Here we see the students off on an outing in the 1920s. The charabanc is a Golden Butterfly. St George's Place was constructed in the 1820s and all fifteen buildings are now listed.

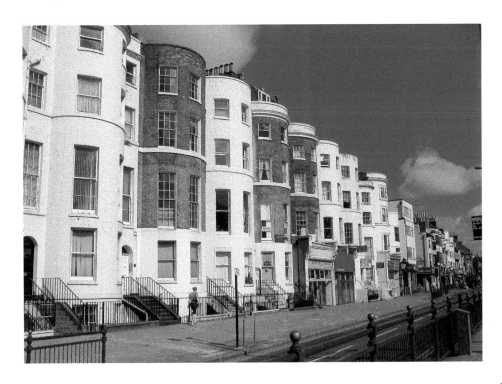

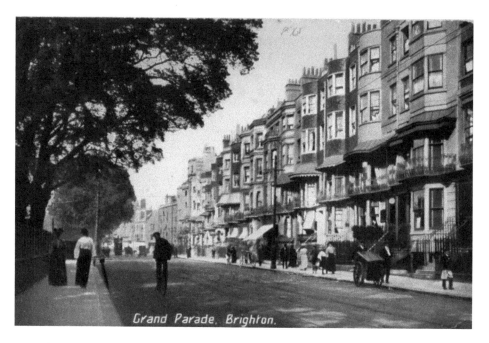

Grand Parade, Brighton.

Grand Parade

Grand Parade still preserves some of its elegance in a terrace of dissimilar buildings. While some properties have retained their balconies, the canopies have mostly gone. In the recent view the houses are dominated by the modern building belonging to the University of Brighton.

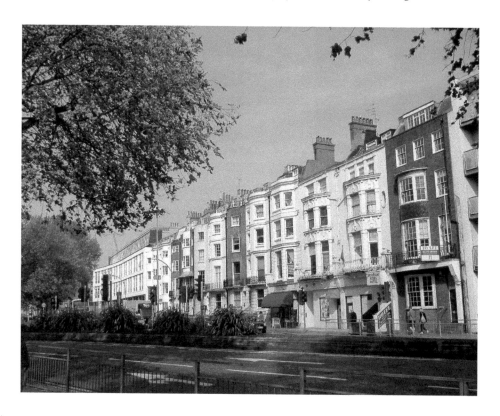

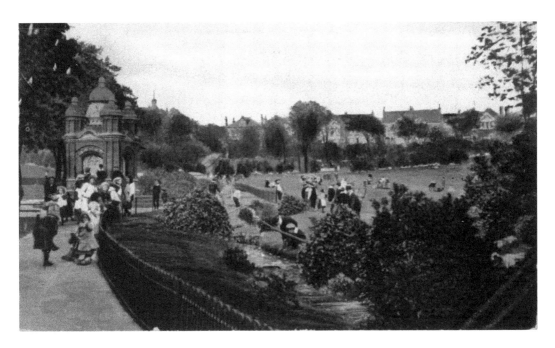

Queen's Park

Queen's Park has been a pleasure garden since 1824 but only subscribers were allowed in. In 1834 it was named after Queen Adelaide and in 1891 the Race Stand Trustees purchased it and presented it to the town. The postcard depicts a little stream that no longer exists but the red brick and terracotta drinking fountain remains.

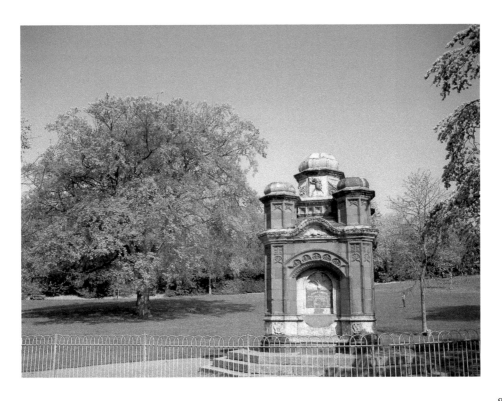

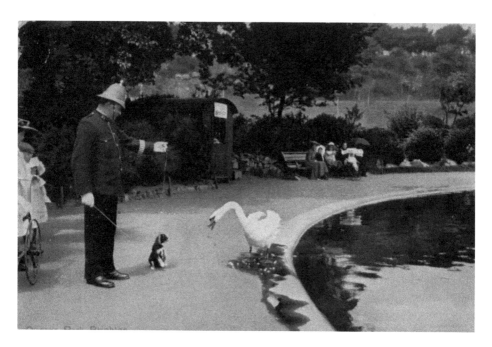

Queen's Park

There used to be a large roller-skating rink in the valley and it was Brighton Corporation that created the beautiful lake. The policeman looks as though he is wearing the white helmet of the Brighton police's summer uniform. In fact the postcard dates from 1906 and white helmets were not introduced until 1933.

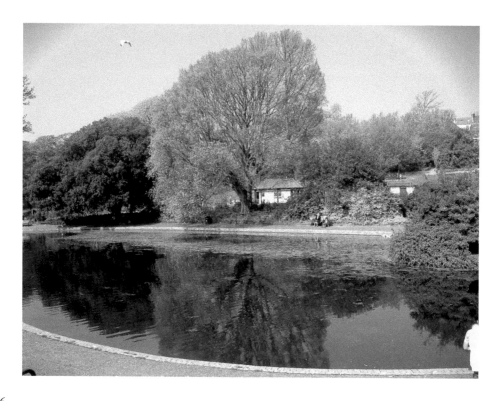

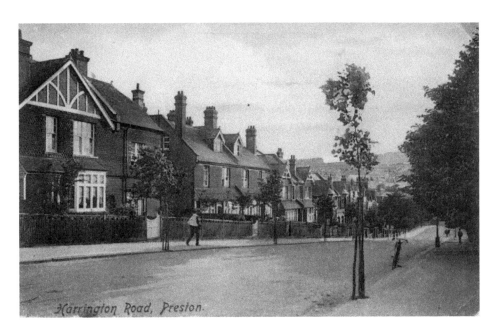

Harrington Road, Preston.

Harrington Road

Harrington Road has some solid red brick residences dating from the 1890s. Mr and Mrs Olguin of Coolavin, Harrington Road, selected this view as their 1906 Christmas card with their name and address printed on the back. This particular card was sent to John Pocock, their bank manager in Hove.

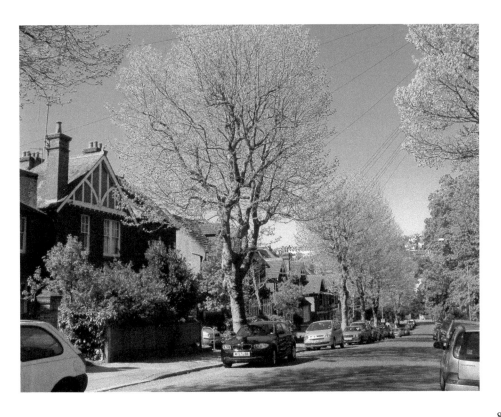

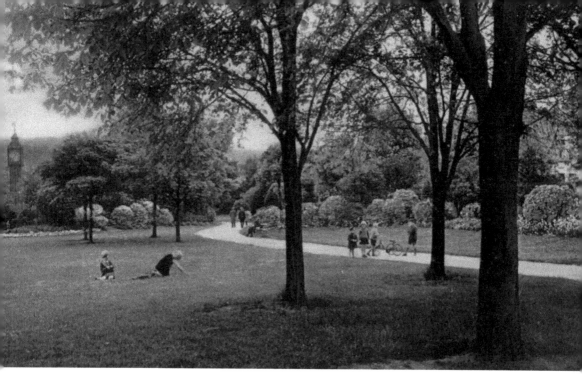

Blaker's Recreation Ground

In 1893 Sir John Blaker donated the recreation ground that bears his name and it opened the following year. He also paid for the impressive steel and cast iron clock tower standing 50ft high. It cost £1,000 and he inaugurated it himself in 1896 when he was mayor. The recent view shows the tower is in sparkling form.

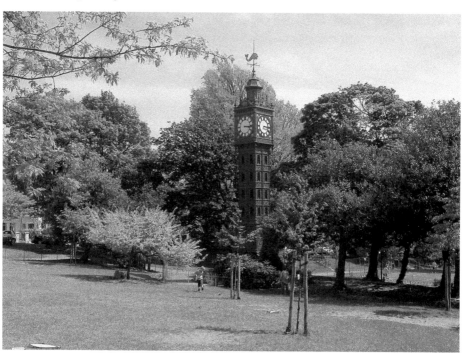

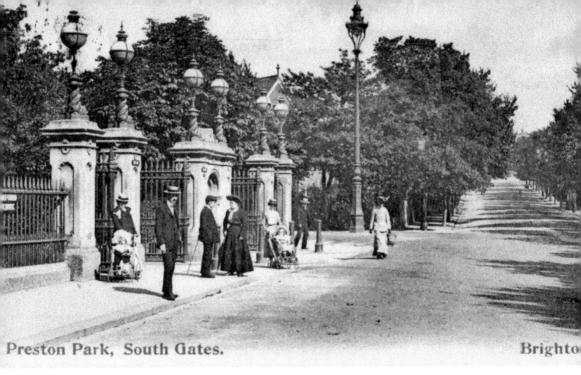

Preston Park, South Gates. Brighto

Preston Park

Preston Park was once some 60 acres of meadowland and Brighton Corporation purchased them in 1883 for £50,000. The deal was possible because of a large legacy from bookmaker William Davies. The south gates with imposing piers and dolphin lamp standards proclaim civic pride. The second view reveals all that is left of them today.

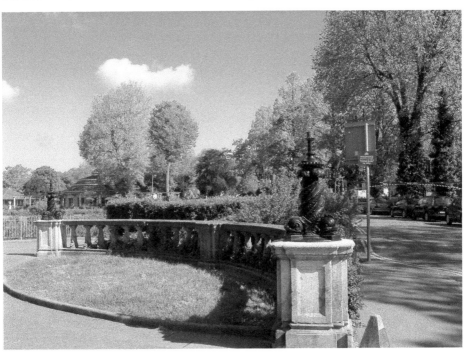

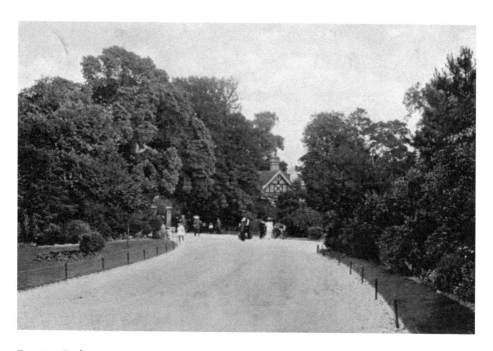

Preston Park

Brighton Corporation spent the enormous sum of over £22,000 in laying out the park. This included bowling greens, tennis courts, flowerbeds and trees, railings, gates and spacious carriage drives. The recent view looks towards the rockery, created in the 1930s.

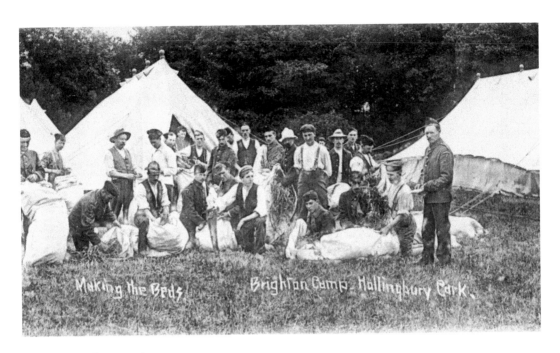

Making the Beds. Brighton Camp. Hollingbury Park.

Hollingbury Park

The volunteers in this 1906 view are 'making the beds' – in other words stuffing the palliasse with straw. The East Surrey Brigade camped at Hollingbury for two years running, arousing the interest of Brightonians who piled into trams to come and watch them drilling. The steep hillside lost many trees in the 1987 storm but has recovered well.

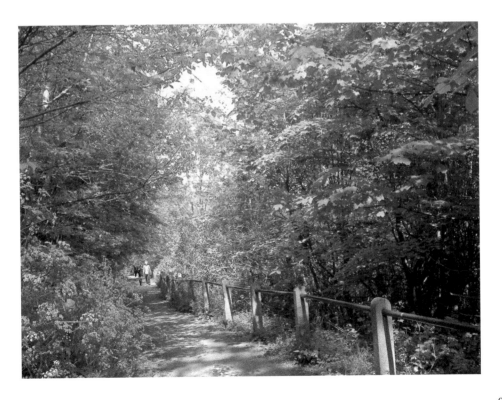

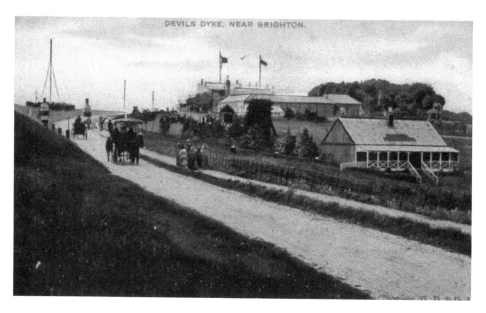

DEVILS DYKE, NEAR BRIGHTON.

Devil's Dyke

Although Devil's Dyke is a deep valley in the Downs, most people use the term for the hill above and from where spectacular views can be obtained. It has long been a popular place to visit. The postcard shows the approach to the Dyke Hotel while the recent photograph looks west to Truleigh Hill.

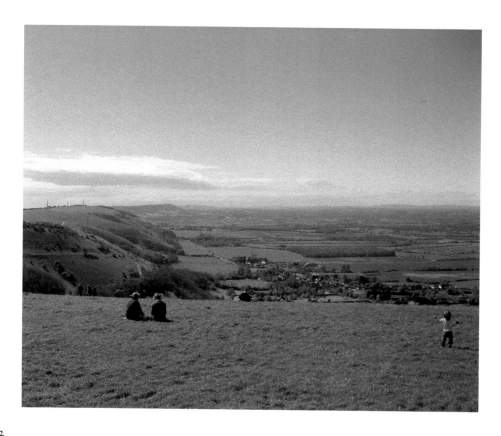

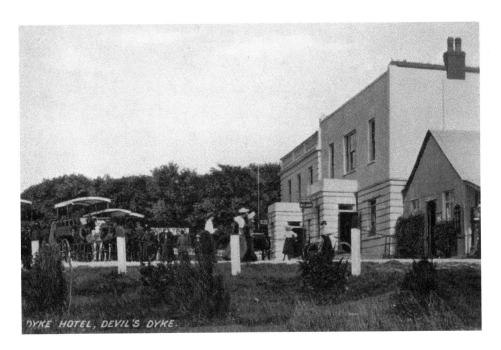

Devil's Dyke

Refreshment was provided at the Dyke from 1817, at first from a wooden hut and then in a small inn, followed in 1871 by the structure pictured in the postcard after it had been enlarged. In 1945 it burnt down and was replaced in 1955 with a new building using local materials more in keeping with its surroundings.

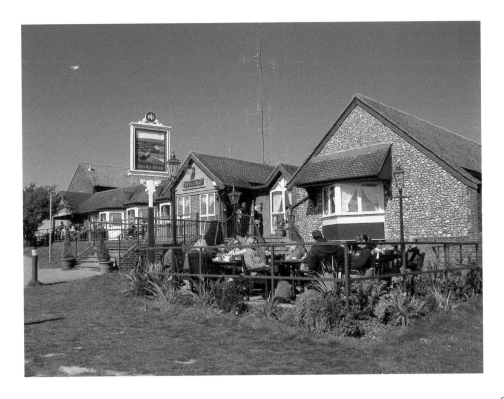

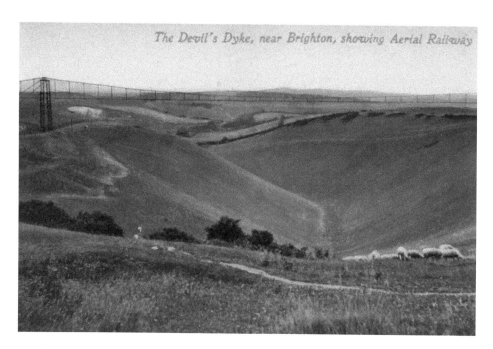

The Devil's Dyke, near Brighton, showing Aerial Railway

Devil's Dyke

The aerial cableway was inaugurated on 13 October 1894. The two steel towers of open latticework were situated 650ft apart and the cable was suspended between them some 230ft above the ravine. The open cage carried eight persons. The cableway only lasted around fifteen years. The modern view looks north over the Weald.

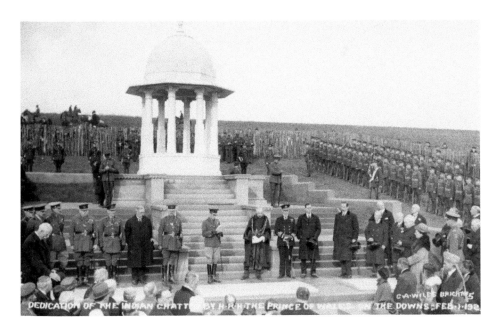

DEDICATION OF THE INDIAN CHATTRI BY H.R.H THE PRINCE OF WALES ON THE DOWNS FEB 1 192

The Chattri

The Chattri, designed by E. C. Henriques, is on the Downs above Patcham and covers the site where Hindu and Sikh soldiers who died at Brighton were cremated. The word Chattri means umbrella and in this context signifies a covering for the memory of the dead. The Prince of Wales (later Duke of Windsor) unveiled the Chattri on 1 February 1921.

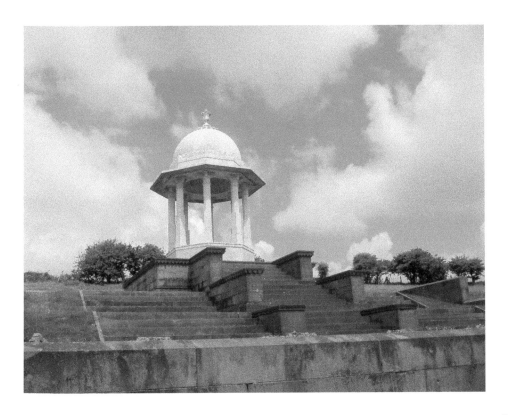

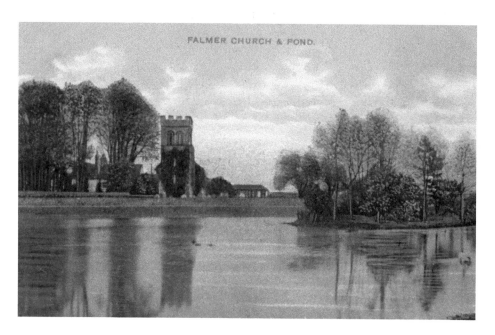

FALMER CHURCH & POND.

St Laurence's Church, Falmer

St Laurence's church, Falmer, is in a most picturesque setting. Although there was a church at Falmer at the time of the Norman Conquest it was not this one, which dates from the nineteenth century. In cold winters people enjoyed skating on the frozen surface of the pond. Not far away the new Brighton & Hove Albion football ground is being constructed.

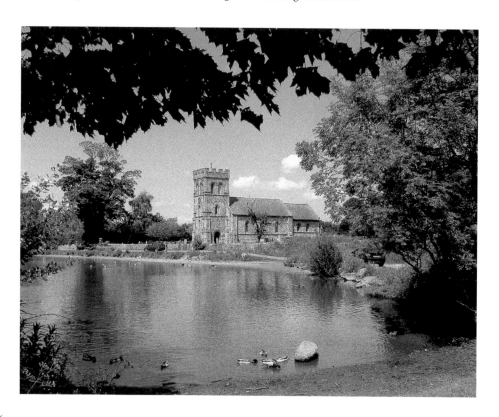